Photography as Artistic Experiment

from Fox Talbot to Moholy-Nagy

8/82

Photography as Artistic Experiment

from Fox Talbot to Moholy-Nagy

W. Rotzler

AMPHOTO
American Photographic Book Publishing Co., Inc.
Garden City, New York

Copyright © 1976 by American Photographic Book
Publishing Co., Inc. for text of English edition

Photography as Artistic Experiment
from Fox Talbot to Moholy-Nagy
is part of a series entitled
PHOTOGRAPHY: MEN AND MOVEMENTS
Edited by Romeo E. Martinex in cooperation with Max A. Wyss

Copyright © 1974 by Verlag C. J. Bucher,
Luzern und Frankfurt/M for German edition

Library of Congress Catalog Card Number 75-34677
ISBN 0-8174-0317-5

English translation: Maureen Oberli-Turner
Photographs printed by C. J. Bucher, Luzern/Switzerland
Text printed in the United States of America

Art, or at least visual art, is always dependent upon the act of seeing. Even when the products of creative activity are not metamorphoses or interpretations of visible reality but take the form of "anti-realities," of "visualizations," of ideas, or of feelings, they are nevertheless perceived through the precise optical instrument of the eye. Poets, musicians, and philosophers may be able to create even if they are blind; but those active in the visual arts are dependent upon the sense of sight in creating works that speak to the viewer's mind through his eye. Visual perception is the prerequisite for both the production and the reception of works of visual art, and this applies particularly to two-dimensional creations, such as paintings, drawings, and graphic art, in which the sense of touch can play no part.

Thus it is no mere chance that artists throughout the ages have always been passionately interested in visual perception in all its forms, and above all in optics. The word "optics" originally meant "the science which treats of light and the phenomena of vision," or more precisely, the physics of all rays similar to those of light. When we think of optics as the science of light and seeing, the first thing that springs to mind is geometrical optics, which deals with light rays in the form of lines through which specific "images" are conveyed; and we are also reminded of the more recent physical optics, or wave optics, which deals with the wave theory of light, as well as the ancient physiological optics, which is basically devoted to the laws of seeing.

All seeing is dependent upon light, and it is therefore understandable that artists have always been occupied with the nature, qualities, laws, and characteristics of light. At the same time, they have always been interested in finding a definite basis for the laws of seeing, and they have never failed to be aware of the divergence between the *objective* laws of seeing and the *subjective* peculiarities of *individual* seeing. The fact that each individual sees "differently" in spite of the undoubted existence of objective laws of light had already irritated and intrigued the artists of Greek antiquity, and this contradiction appears repeatedly as a subject of discussion in the Dialogues of Socrates.

At certain periods, the activities of artists were largely determined by their interest in the laws of optics. This applies particularly to the Italian Renaissance—and in fact the Renaissance as a whole—in which many of the concepts that had hitherto been determined by religious dogma based on the fixed and immovable nature of the world achieved an increasing measure of freedom. Thirst for knowledge began to take the place of religious dogma, and unbiased investigations into the natural laws of the world were carried out on an ever-widening basis. The artists of the time participated enthusiastically in the quest for knowledge, for observation and comprehension have always been a prerequisite for creative activity.

Within the framework of a mathematical way of thinking, which had penetrated the world of art, the artist of the end of the fifteenth century accorded pride of place to the field of optical phenomena. First and foremost, "perspective" was the center of attraction, and the "perspector" was not merely an expert on questions pertaining to the subject of perspective, but rather a scientific observer on a wide scale, who was regarded as being capable of deeper seeing. During this era of the Renaissance, which cultural philosophers such as Jean Gebser considered to be the beginning of "the age of perspective," the laws of lineal perspective were the first to be investigated as part of the scientific geometrical work that was passionately pursued by artists in the mid-fifteenth century, and which was even considered to be an important basis for creative art.

Art, science, and technology were regarded by the progressive thinkers of the Renaissance as related and complementary fields, and even as different facets of one and the same universal, exploratory, and creative activity; and it was not unusual for artists to write scientific—mainly mathematically oriented—treatises or to occupy themselves as technologists or engineers.

Although linear perspective was the first problem to assume importance in the specific field of art, and especially the question of "correct" perspective in the two-dimensional portrayal of space and volume, Leonardo da Vinci (1452–1519)—the *uomo universale* who was little short of being a magnificent embodiment of the aspirations of the Renaissance—nevertheless went considerably further than mere experiments in linear perspective. The ability to make linear, or central, perspective, discovered around 1420 by Florentine artists such as Filippo Brunelleschi, and based on the concept of the vanishing point to which all parallel lines in the same plane tend, had already been accepted as a matter of course by Leonardo. He was chiefly interested in the possibilities of light or color perspective, that is, a spatial arrangement in his pictures, which took into account the difference in depth-of-field associations produced by the use of specific colors: reds and yellows for close-up objects and blue tones for distance. In addition, he attempted to make use of specific areas of optics—for example, the relation of sharpness to unsharpness—in his painting. At the very least, he succeeded in creating documents on the theme of "focal seeing."

Leonardo da Vinci's interest in the work of the scholars of his time, who were boldly progressing into many areas of knowledge, was thoroughly in accordance with the spirit of his age, and he did his best to make use of their discoveries—for example, in the field of optics—in his own personal artistic explorations. His interest in the "camera obscura," or "dark chamber," which was basically a kind of

pinhole camera, and which was to become one of the most important prerequisites for the invention of photography, was a case in point. It is not known exactly when and by whom the camera obscura was first discovered; its principle was certainly known to the ancient Greeks through the physics of Aristotle, and the Arabian mathematicians and opticians were also familiar with the concept. The first precise description of the camera obscura appears in the *Opus Maius* of 1267, the chief scientific work of the English Franciscan monk Roger Bacon. The camera obscura, or pinhole camera, made it possible to demonstrate how light rays entering an enclosed area with dark walls through a tiny hole appear in the form of a projection on the back wall. The pinhole functioned as a lens in which the light rays crossed and accumulated according to the principle of conversion and divergence, thereby producing the somewhat surprising phenomenon whereby the image of, say, a person or a house appears in an inverted form on the back wall of the camera obscura.

Leonardo da Vinci, who took an intense and active interest in this piece of technical equipment which was familiar to the artists of his day, wrote about it in his diary as follows: "When the façade of a building, a city square, or a landscape is exposed to sunlight, and a small hole is made in the shutter of a window in a wall facing the object and not illuminated by sunlight, the illuminated object throws its image through the opening and appears inverted on the back wall of the room. When this image of the sunlit object is captured on paper in the room, it takes on the appearance of a self-drawn image. The paper should be very thin, and the image is then viewed from the reverse side." What Leonardo described is exactly the same phenomenon as that which was observed by early photographers on the groundglass screen of an early camera with its shutter held open.

The technical aspect of the camera obscura as an early predecessor of the camera is not, however, of primary interest to us here. Naturally enough, it was not long before the pinhole was replaced by a convex lens, as described by Girolamo Cardano from Milan as early as 1550. More interesting is the fact that Giovanni Battista della Porta, in a scientific work written in 1558, not only described the camera obscura but also emphatically recommended its use to artists as a working aid; and not only did he advise the use of a lens, he also recommended the installation of a convex mirror in the camera obscura so that the picture would appear not back-to-front but "correctly" projected on the wall or some transparent medium in the desired size, thereby anticipating the principle of the mirror-reflex camera. The further development of the camera obscura into an efficient and handy instrument belongs to the prehistory of photographic technology.

For our purposes, the pertinent fact is that artists have used this optical instrument as a working aid for painting and drawing ever since the Renaissance. This presupposes a specific relationship to visible reality; and as long as this relationship had no real part to play in the field of art, which was basically the case in medieval art until the emergence of realism in the fifteenth century, there was no interest in aids toward the creation of exact and precise likenesses of visible reality. The fascination that the camera obscura held for the Renaissance artists was based on the fact that it made it possible for reality to virtually represent itself by the projection of three-dimensional objects on the two-dimensional surface of a transparent medium, such as paper or a ground-glass screen. Of course, the art of Leonardo da Vinci and his contemporaries makes it clear that the "natural likeness" produced by mechanical means was not an end in itself but rather a useful aid in the production of individual creative work. What fascinated the Renaissance artists was the mechanical, self-acting conversion of spatial and corporeal reality into a plane-surface image and the phenomenon of the simultaneous similarity and dissimilarity of the object and its representation.

This was perhaps most clearly demonstrated by Albrecht Dürer (1471–1528), to whom geometry was not only a prerequisite but also an essential part of all creative art. In a woodcut made in 1525, he illustrated the principles of foreshortening and projection using a simple drawing instrument that was in common use at the time. The woodcut shows a lute lying laterally on a table; the artist observed the instrument from the side through a sheet of transparent paper spanned in a frame, and outlined its contours from his severely foreshortened angle. The wide difference between the corporeal object and its image viewed from another angle is an impressive illustration of the divergence between the true nature of things and their appearance. The artists of the Renaissance were sufficiently intellectually alert and versatile to recognize the philosophical implications inherent in observations and demonstrations of this kind.

The later counterpart to the camera obscura, the "camera lucida," or "light chamber," gave rise to similar and supplementary considerations. This was a drawing aid basically consisting of a prism fastened to a rod above the artist's drawing table. Through a small peephole above the edge of the prism, which was fixed at eye level, the artist could observe both his subject—for example, a seated model—and his drawing paper simultaneously; thus he only had to trace with his pencil the form of the subject appearing as a projection on the paper in order to obtain a faithful likeness in reduced size. The Englishman William Hyde Wollaston developed the camera lucida into a portable drawing instrument in 1807 and made, as well as drawings, copperplate engravings

of landscapes with its help during a visit to America. He thus discovered a mechanical method of producing etchings, from which a large quantity of paper copies could be printed with a handpress.

This mechanization, and with it acceleration and rationalization, of image production corresponded to the conviction inherent in the enlightened eighteenth century that a rational and technical production of artistic works, which had hitherto been entirely dependent on the artist's manual skill and feeling for form, was perfectly possible and feasible. The *Encyclopédie* of Diderot and d'Alembert, which appeared between 1751 and 1780, is a stupendous and epoch-making product of the spirit of this age which embraced the practical use of all scientific and technical knowledge.

Like its predecessors—the many different kinds of equipment for the semimechanical production of silhouettes, or shadow pictures, on a white paper ground—the camera lucida also reflected an artistic and sociological phenomenon: Beginning with the Renaissance, which can justifiably be called the age of the discovery of the individual, the portrait gained increasingly in importance as a means of capturing the individual facial features and, at the same time, as a new branch of painting. At first, however, it was only the socially privileged who could afford to have their portraits painted in several sittings; but with the strengthening of the bourgeois society in the towns, the social ascent of the "third class," and the increasing democratization of the social structure, the demand for personal portraits grew in proportion to the improvement in social conditions. This, of course, gave rise to the need for a quicker and cheaper method of making portraits, and this demand was met in the eighteenth century—and above all after the French Revolution—by an ever-increasing number of optical drawing aids that facilitated the quick, mechanical, and "faithful" production of portraits, not only by professional artists but also by clever amateurs.

The "physiotrace" (approximate translation: "face-tracer"), invented by the Frenchman Gilles Louis Chrétien in 1786, was a technically improved version of the numerous silhouette devices based on the shadow-picture principle. It was capable of producing not just a single drawing but a fine engraving on copperplate which, when re-etched, made it possible to print several copies of the same image. Thus the production of pictures, particularly of portraits, was already quicker and considerably cheaper at the beginning of the bourgeois era. Reproduction by semimechanical means, which had been employed in letterpress printing and in the graphic arts since the end of the fifteenth century, was a part of this method of picture-making invented by Chrétien. The fact that 600 pictures made with the physiotrace were shown in the Paris "Salon" in 1797—up till then an art exhibition in the

strictest sense of the word—is proof that the mechanical image-making methods were an answer to a real demand, and that it quickly became possible to produce technically satisfactory results. The coming invention of photography was already in the air; and it was not only the prevailing obsession with research and discovery, the play instincts of the *homo faber*, and the commercial demands of the time that were to provide the final impetus, for the intellectual soil propitious to the advent of photography was a positivistic way of thinking concerned with making the whole of reality perceptible—in short, a materialism that regarded material actuality as the only valid reality.

All the optical equipment used in the two-dimensional representation of visible reality, which had been developed since the sixteenth century, was more or less dependent on the skilled hand of the artist, for the projected image of the illuminated object, which appeared on a suitable medium through a lens, had to be outlined and fixed by hand with a pencil, engraving tool, or paintbrush. It is therefore understandable that repeated attempts were made to find the final missing link in the chain, which was to lead finally to a self-acting, mechanical means of picture-making.

Since it is light that transports the image in the case of all optical apparatus, it was necessary to find a medium which could be "sensitized" so that it would automatically and spontaneously capture and retain the light rays to which it was exposed. This problem, which was no longer optical but chemical—or in today's terminology, photochemical—very soon began to occupy a large number of independent researchers. The best progress was made by a doctor named Johann Heinrich Schulze (1687–1744), in the Prussian town of Halle, who discovered in 1727 that silver salts became discolored and blackened, not by heat but by the influence of sunlight. During the course of his experiments, Schulze filled glass jars with a solution of chalk and nitric acid that contained dissolved silver. He then stuck shapes and letters cut out of paper onto the jars and exposed them to sunlight. When he removed the cutouts from the jars some time later, their shapes were imprinted white against the blackened sections of the silver salts solution that had been exposed to the sunlight.

Although Schulze was not able to retain, or fix, his images for any length of time, he had nevertheless ushered in a powerful and unrestrainable development which, decades later, led to the production of light-sensitive materials for the creation of light-images that could be made permanent by chemical treatment with fixing salts subsequent to exposure. Schulze's discovery of light-sensitive substances was in fact a continuation of experiments that had already begun—although with the use of other chemical processes—in the illustration of books on nat-

ural science: the so-called "nature prints" in which the forms of leaves, grasses, and similar natural objects were imprinted on copperplates by means of ingenious pressing and etching techniques without the use of manual drawing. These "nature prints," examples of which are preserved in plates from the seventeenth and eighteenth centuries, as well as Schulze's "light graphics," are really distant predecessors of another genuinely photographic experiment—the photogram—which is produced on light-sensitive material without the help of the camera.

The so-called invention of photography is really a compound of numerous discoveries and developments in the fields of optics and chemistry, some of them centuries old, which combined to form a complete and independent system that provided the answer to a great many different demands. Although other investigators—for example, the Englishman Tom Wedgewood (1771–1805), who very nearly achieved his goal in 1800—also carried out intensive research, it was Nicéphore Niépce (1765–1833) who was the first to produce pictures by means of light alone. With his camera obscura fitted with a simple lens, he made images on light-sensitive material—glass, copper, or paper—and subsequently fixed them in an acid bath; these images were called "heliographs" (meaning sun-drawings, from the Greek *helios* = sun and *graphien* = to draw or etch) by their creator. It was only later that another pioneer in this field, the Englishman Sir John Herschel (1792-1871), created the somewhat broader concept of "photography" (meaning light-drawing, from the Greek *photos* = light). Niépce succeeded in producing negative images, and although they were over 20 years ahead of the "Daguerreotypes," the clever self-advertising and social prestige of the theatrical designer Daguerre overshadowed Niépce's brilliant achievement—and still tend to do so even today.

Although he was intensely interested in the technique of lithography invented by Senefelder in 1796, Niépce was not an artist, even though it was during technical experiments in lithography that he hit upon the method which enabled him to make paper and other materials sensitive to light. Naturally enough, Niépce worked hard on the problem of converting his negative images into positive pictures so that the light sections would appear really light and the dark really dark, and it was even his most cherished dream to capture his subjects in their natural colors. The few existing examples of Niépce's photographic achievements—he called his pictures *points de vue* (viewpoints)—are views from the windows of houses and still-lifes photographed indoors. It was Niépce's aim to "copy nature as faithfully as possible" with the technical methods he had evolved, and which he constantly developed and improved, due partly to his restless technician and inventor's desire for perfection in his work, and

partly to the opinion prevalent at the time—and indeed still today—that the highest aim of all visual representation—and thus also of art—is the absolutely faithful and accurate likeness. This conviction that nature was the *non plus ultra* and the resulting demand for the greatest possible degree of faithfulness in the image were thoroughly in accordance with the artistic ideals that had been set at the end of the eighteenth century by the classicism of, say, Jacques Louis David, and that consisted of an exact and penetrating representation of reality, which was expressed most clearly in portraits, still-lifes, bourgeois genre pictures, and landscapes. At the time when Niépce was busy trying to capture visible reality mechanically and with "objective faithfulness," it was fashionable in the world of progressive art, and especially in France, to break away from this ideal which had become so sterile, and the development parallel to the invention of photography was the pathetic protest that took the form of the romantic painting of a Delacroix or a Géricault.

The situation of the other pioneer of photography, Louis Jacques Mandé Daguerre (1789–1851), was somewhat different. The exciting but sometimes tragic early history of photography relates that this worldly Parisian, obsessed by new discoveries and effects, learned of Niépce's experiments, descended upon him in his country home, and tried for years to persuade him to agree to a collaboration that finally reached a conclusion in the famous contract between the two men in 1829. There is no doubt that Daguerre had already used the camera obscura in his work as a stage designer, and that his aim in art was largely the production of illusionistic images and of an easily comprehensible type of art which, in its superficial faithfulness to reality, appealed to a wide public. The highlight of his aspirations was the "Diorama," which Daguerre opened in Paris in 1822, in which multilayered pictures of historical or folkloristic themes painted on huge expanses of gauze gave the illusion of movement through illumination by constantly changing lighting. It is not known for certain how far Daguerre himself had progressed in photographic experiments before his contract with Niépce. In any case, he developed Niépce's processes considerably after the latter's death. His own invention was the silver layer sensitized by iodine vapor on a copperplate that could be developed after exposure by mercury vapor and subsequently fixed. Daguerre proudly named this process for the production of positive images "Daguerreotypie" in 1837, and in 1839, it was made public under this name by the astronomer Dominique François Arago in Paris at a remarkable meeting of the Académie des Sciences and the Académie des Beaux-Arts, thus becoming accessible in theory to the general public.

The innovation of the production of light-images of visible reality by the new methods caused a sensa-

tion all over the world. The name of Daguerre became a household word, and that of Niépce remained unknown or was suppressed. An astute businessman, Daguerre had cameras, films, and instruction pamphlets produced on a mass-production basis, and the equipment bearing his name sold like hot cakes. The making of Daguerreotypes quickly became a fashionable activity in a progressive era that suffered from a certain giddiness caused by a glut of epoch-making technical inventions.

Naturally enough, Daguerre himself made the best possible use of his invention, and he was able to produce single positive images of astonishing sharpness. The oldest Daguerreotype by Daguerre is a kind of studio still-life consisting of an arrangement of plaster casts, wicker bottles, draped material, and a picture. It is evident that the objects were specially set up for the exposure, but the intention was not a consciously posed and "pictorial" still-life, as was usual in the field of painting, but rather an atmosphere of casualness, as if the objects had been placed by chance in the corner of the studio. The interest in showing the three-dimensional moulding and light and shade of the objects was still in the foreground, and the intentionally posed and arranged pictures were to follow later on.

Leaving aside the rapid developments and improvements in photographic techniques that ensued after Daguerre's process had been made public, the question arises as to the use the pioneers of photography made of the new picture-producing medium. What did they aspire to, and what did they achieve? Since the products of photographic technique are basically transpositions and fixations—in this case, mechanical, optical, and chemical—of three-dimensional reality on a plane surface, the analogy with the processes of drawing and painting is bound to crop up, since all three operate with and on the plane surface. And thus a second question arises: How did contemporary artists react to this new visual medium?

In the first place, the early photographers had to come to terms with the fact that they were limited to portraying polychrome reality in shades of black and white, that is, in graduated colorless tones ranging from white to black. How aware were they that the supposed "natural likeness" was really nothing other than an "abstraction" of reality, and not least of its polychromy, an abstraction closely related to that of drawings, ink washes, and monotone graphic printing techniques? How far did the photographic pioneers recognize, perceive, and consciously use the creative possibilities inherent in this abstraction from color? The question has no simple answer, at least as far as the early years of photography are concerned, partly because it is often far from easy to decide with any certainty which pictures were the result of chance and which were consciously created, and partly because—at least to our modern

eyes so used to black-and-white abstractions—certain technical imperfections or unfamiliar elements in the portrayal of space and volume in the images seem to have a spontaneous, awkward charm and sometimes even an undefinable, imaginative quality. At the same time, these incunabula of photography are so full of information about the people, conditions, and mood of their time that their interest to posterity as documents of an era somewhat overshadows the purely formal and visual aspects.

On the whole, however, there seems to be no doubt that both the early photographers and their public regarded photography as a medium for the production of images similar to paintings. Thus photographers were tempted to try and imitate the (in their eyes exemplary) medium of painting and to work according to its principles of form and composition, and even of light and shade. This element of imitation is present in most of the portraits, which were considered to be by far the most important aspect of photography, and especially of Daguerreotypy, in the early days of the medium. It would not be difficult to find examples of the painstaking precision with which the photographer tried to copy the rules of portraiture established in painting, for example, the pose, placement in space, angle of the head, and so forth. The portraits by Ingres, which were considered unparalleled by artists and bourgeoisie alike in the period following 1840 due to both their general appearance and the subtlety and precision of their detail, are reflected in photographic portraits made at the same time. Even taking into consideration the fact that it was impossible for the photographer to avoid a certain static quality of pose due to the extremely long exposures that were still necessary—thus forcing his sitter to adopt the same rigidity demanded by the painter—there can nevertheless be no doubt that portrait painting remained the model for portrait photography for quite some time.

The situation regarding still-lifes was somewhat similar to that of portraiture. The still-life was particularly popular with photographers, partly because its static nature did away with problems of unsharpness caused by long exposures, and also because it provided attractive and effective subjects from everyday life that were eminently suited to the quest for natural likeness. For the arrangements of "picturesque" still-lifes, the photographer often adhered strictly to the choice of subjects common in still-life paintings, such as can be seen in the works of the seventeenth-century Dutch painters and their successors right up to the present.

Even in nude photography, which was comparatively rare due possibly to the prudery of the time, photographers were largely influenced by post-Renaissance painting, from Titian to Ingres, which they often slavishly imitated with the result that the nude study achieved an unfortunate "posed" effect. In a

nutshell, the photographer drew the inspiration for his choice of subject and composition of his pictures from the museum.

This also applies to the artificial, theatrically arranged group pictures in which the "actors," sometimes even wearing costumes, formed rigid historical, literary, or folkloristic scenes. Thus photography verged upon the field of genre and historical painting, which it intensified into an exaggerated theatricality and false sentimentality by an overemphasis on the allegorical elements. The relationship between these genre photographs and the genre and historical paintings of the time, and particularly the so-called salon paintings, is abundantly clear. The mid-century salon painting was an authentic reflection of the interests, ideas, and desires of the bourgeois society of the time on the one hand, and a portrayal of the secret longings of this same society on the other. The sometimes intentionally funny results of the mock reality, which genre photography borrowed from salon painting, reveals the artistic ineptitude of a great many photographers who, in their blind devotion to the fashionable salon art, completely failed to recognize the superb and unique quality inherent in photography—veracity. There is, however, a difference between this falseness, which is a genuine and therefore historically interesting reflection of the tendencies of the time, and the natural, unposed, and unpretentious figure and group pictures by the real initiators of an authentic style of photography independent of painting, which also made its appearance soon after 1840.

From the beginning, it was in the portrayal of aspects of contemporary city landscapes that photography evidenced the smallest degree of the influence of painting, and the picture of a Paris boulevard, taken by Daguerre as early as 1839, is a genuinely photographic image of a contemporary city scene; the view from a window of a multistoried house over random foreground buildings shows a street lined with unhomogenous, almost chaotic buildings stretching into the distance. The boulevard is almost deserted, and it would seem that Daguerre wanted to eliminate the blur of moving people and vehicles by taking the picture in the early morning. There is but one man visible in the foreground; he is seen having his shoes polished by a bootblack, and he is allegedly the first human being ever to appear in a photograph.

The flood of Daguerreotypes, which spread with extreme rapidity from France over the whole of Europe—to England, in particular—and to the United States, affected scientists, experimenters, artists, and laymen alike. Thousands of cameras and millions of plates were manufactured; professional studios sprang up like mushrooms to meet the huge demand for photographs, and especially for portraits. Everywhere, Daguerreotypists turned their attention to improving the construction of cameras, lenses, shutters, films, and photochemical processes, and Daguerreotypy became a useful and flexible instrument for the understanding of new areas of the visible world.

As if intoxicated, the whole era fell greedily upon the new visual medium of communication, now virtually public property, which broadcast images of new or hitherto unnoticed aspects of the world. New, unknown, or previously unrecognized elements were consciously observed for the first time in the most familiar to the most unfamiliar of objects. The "self-made image" of visible reality, which was generally regarded as being objective and incapable of deception, assumed an authenticity and persuasive power to which no one was immune. One of the most fascinating aspects of the Daguerreotype was considered to be its ability to "arrest time," that is, to extract a phase—which became ever shorter parallel to technical developments—from the continuity of time and conserve it as a static picture. The camera was thus regarded as being capable of interrupting the flow of time, capturing the transitory, and endowing the fleeting with an aspect of permanence.

In this, it is interesting to note the surprising extent to which the development of photography corresponded to the development of the bourgeois society. There is a good reason to believe that the bourgeoisie, which had been actively seeking to establish its true position in society since the Revolution of February 1848, was able to identify with photography to a far greater degree than it had been able to with "higher art," perhaps because in the eyes of the *citoyen*, art was still inextricably bound up with the glorious heritage of the privileged ruling classes. Photography, on the other hand, was unburdened by tradition and provided a quick, comparatively cheap, and above all modern technical means by which the bourgeois and petty bourgeois alike could obtain a more or less faithful likeness of himself. Through photography, he was able to convince himself of his existence and submit his environment to documentary proof. Some time ago, the photographer Gisèle Freund made an attempt to illustrate this parallel rise of photography and the bourgeoisie in a sociological study entitled *Photographie und bürgerliche Gesellschaft* (Photography and the Bourgeois Society).

The immense quantity of Daguerreotypes, of which only a small fraction has been preserved, was made up of a great many insignificant images, a fairly large proportion of thematically interesting and even valuable documents, and a few really important creative works. The latter were partly the products of chance, but partly the results of conscious creative involvement with the photographic medium.

Independent of all phototechnical, cultural, and historical interests, the increase in the quantity of

photographic images gave rise to the question of their formal and creative—and thus artistic—value. Personalities began to arrive on the scene for whom neither the technical nor the documentary aspects of the medium was enough and who—consciously or instinctively—worked toward a comprehension of the specific possibilities and uses of photographic picture-making. Among their achievements was the evolution of the "photographic eye," or "photographic language," and they thus ushered in a development that justified the designation of photography as an independent art. These early photographic pioneers were the predecessors of the impressive number of "master photographers" who emerged in the second half of the century and endowed photography with artistic prestige by making full and satisfactory use of all its possibilities and proved that the most important element is not photographic technique but the man behind the camera.

Some of the pioneers of "artistic" photography came to the medium from the field of actual art in which they were active as painters or draftsmen, although generally of no great significance; in photography, they found a medium adequate to their needs, and many of them progressed further than scientific or technical experiments to specific creative picture-making. These early masters formed the highlights of the first chapter of the "World History of Photography"; but it is not with them and their individual photographic style, which had an important influence on the evolution of a deeper, truly photographic way of seeing, that we are here concerned.

How did painters and other artists who continued to believe in their art and their own creative mediums react to the omnipresent and turbulent development and spread of photography? There is no simple answer to this question, for various and sometimes contradictory positions were taken up. Leaving aside the painters (usually of lesser standing) who simply exchanged the paintbrush for the camera, the chief interest was centered around the possibility of using photography as an aid for drawing, painting, and sculpture, much as they had previously employed the camera obscura. Important painters, from Eugène Delacroix to Edgar Degas, took advantage of this possibility, particularly in France, and they either took their own photographs, ordered them from professional photographers, or used existing images. It is part of an intriguing—and up till now underestimated—task of art history to establish by means of concrete cases how extensively and how successfully individual painters used photographs taken by themselves or others in their work, and the degree to which specific photographic elements are present in their paintings.

The first systematic investigation into the mutual contact, influence, and consequences of art and pho-

tography, particularly in the nineteenth century, was published by the art historian Otto Stelzer in his work entitled *Kunst und Photographie* (Art and Photography), in which he incorporated single factors, some of them already recognized, in a complicated system of mutual give-and-take. We have already seen that photographic picture-making was at first almost slavishly dependent upon painting, and the fact that no less an artist than the romantic painter Eugène Delacroix made his sketches from photographs of nudes, animals, and groups is all the more interesting in view of this mutuality. Particularly remarkable is the case of the most important master of late classical painting, Jean Auguste Dominique Ingres (1780–1867) who, in spite of signing a protest against photography by the Paris artists petitioning the government to forbid photography on the grounds that it represented unfair competition to painting, nevertheless commissioned the photographer Nadar to take nude photographs of the model Christine Roux on the basis of which he painted his famous picture entitled "La Source."

It was the portrait painters on all levels who made the greatest use of photography as a working aid since the middle of the nineteenth century, a fact proven both by documents and by analysis of the portraits themselves. In the "Self-Portrait with Family" by the fashionable Munich painter Franz von Lenbach, for example, the painter made no attempt to disguise the fact that he had "dashed into the picture" at the last minute after setting the automatic shutter release, and the painting shows him bent over in a comical, distorted attitude to prevent the top of his head from being cut off in the photograph.

The great realist Gustave Courbet painted his famous picture of Chillon Castle on the Lake of Geneva based on a photograph by Adolphe Braun. Right up to Paul Cézanne, great painters constantly used photographs as working aids for whole pictures or for single elements—painters whose standing exonerates them from any suspicion of the need to "copy" in their pictures. Even Rodin reverted to an old Daguerreotype in 1892 when working on his memorial to Balzac. The list of such examples is virtually never-ending and includes cases in which the painters themselves took photographs for use in their work. Discussing the Paris "Salon" of 1861, the poet Théophile Gautier wrote: "Although photography received no award and was indeed not even mentioned, it nevertheless played a big part in this exhibition. It provided study material, replaced the posed model, furnished props, drapes, foregrounds, and backgrounds—in fact, all that was necessary was to copy and color it."

Edgar Degas, however, did not stop at copying. Himself an enthusiastic photographer, he owned one of the earliest snapshot cameras, and he often participated in the developing and printing of his

pictures. The poet Paul Valéry once wrote in a letter: "Degas loved photography, and he freely admitted —as most artists did not dare to—that he used it in his work. He made some very fine photographs." Valéry also emphasized that his friend Degas knew exactly how far he could profit from the use of photography, and it was his aim "to endow the instant photograph with a quality of permanence through patient meditation." In spite of his sublimation of the photographic "raw material" in painting, Degas not only allowed typical photographic elements to remain in his paintings, he even turned them into characteristics of his style—for example, the distortion of figures or other subjects toward the edge of the picture, or unsharpness and distortion in the near foreground (typical of the use of lenses of extreme focal length). For Degas, as for Toulouse-Lautrec some time later, the "chance" movement captured in the instant photograph—for example, of figures entering or leaving the picture—was of the utmost importance, and this led to the "cutting" of some of his figures which, although disdained by those bound to conventional "composition," was a characteristic of Degas's paintings. This "cutting" was also a means of bringing the element of movement and life to the picture, which was, of course, static by nature.

There was yet another reaction to the growing spread of photography which, although less precisely tangible, was more widespread and far-reaching. Although photography was the ideal democratic medium that was able to satisfy the huge demand for pictures, that is, for the representation of certain aspects of visible reality on a scale that would have been impossible for painting, it also represented a functional competition to painting, and above all to the conventional, even epigonal, commercial art, which was what portraiture on a commissioned basis really was. Genuine creative art suffered hardly at all; on the contrary, it at last succeeded in shaking off the fetters imposed upon it by practical hack work, although this in its turn may have meant a decrease in its social function and material security. Be that as it may, the rise and spread of photography resulted in the liberation of free painting from realistic representations of visible reality, which endowed it with a degree of artistic independence. The spread of photography, which began around 1850, certainly played a part in the artist's break with his social ties and responsibilities and his retreat to an existence on the borders of society. Henri Murger's novel *Scènes de la Vie Bohème*, written in 1851, provides an apt reflection of the artist's new way of life as an outsider.

As regards the artistic aspect, this development signified an increasing preoccupation, particularly in the case of painters, with purely creative problems such as those which occupied the impressionists and which reached their climax with Cézanne and his contemporaries before finally leading—via cubism—to abstraction around 1910. From the human point of view, the development, which might also be regarded as an alienation, meant that the artist concentrated more and more on his own problems, and a certain subjectivism ensued, which was strikingly and tragically reflected in the life and work of Vincent van Gogh. This subjectivism was for the most part diametrically opposed to the objectivism of the realistic photographic document, and it was the source of both the symbolism that prevailed at the turn of the century, and still more important, the early expressionism founded by van Gogh, Paul Gauguin, and Edvard Munch.

Ever since the photographic medium began, there have been personalities active in the wide area between pure photography—photography concerned with producing faithful likenesses of visible reality— and pure painting as it has developed over the centuries. Regardless of whether they came originally from the field of art or photography, these personalities were inspired by individual motives to use the medium of photography or certain photographic techniques for their own, often highly unorthodox, creative experiments which, in their turn, enriched both photography and art. Virtually since photography's beginning, these artistic experiments with photographic methods have accompanied the medium's development. In many cases, the experiments remained isolated examples that had no influence on further developments; others, however, had a direct or indirect effect upon the evolution of photography and/or art, and especially on creative activity and the artistic way of seeing. Still others were directly connected to basic changes in the artistic conception as a whole, and in their turn often had a considerable influence on specific artistic trends.

The first of these experimenters with photographic mediums was undoubtedly the Englishman WILLIAM HENRY FOX TALBOT (1800–1877). This mathematician, philologist, and man of letters who was a great scholar as well as a great humanist, was both a pioneer in the technical development of photography by virtue of his phototechnical experiments and discoveries, and one of the earliest—and perhaps even the very first—"master photographer," as can be seen on the basis of his extremely fine photographs. He was in fact a key figure in both photographic technique and photographic art.

Fox Talbot's interest in photography really started because he could not draw as well as he would have liked to. During a stay in northern Italy in 1833, he tried unsuccessfully to make some landscape drawings with the aid of Wollaston's camera lucida. He then reverted once again to the camera obscura, with which he had previously worked, and tried to project the landscapes onto a transparent medium so that he could trace their outlines. This led him to

the idea that it might be possible to find a way of fixing the images on paper, and after his return to England, he began experimenting with methods of making paper sensitive to light. He finally achieved some measure of success with a solution of silver nitrate; since the contrasts in the images thus obtained were insufficiently strong, Fox Talbot then saturated the paper in sodium chloride before coating it with silver nitrate, thus obtaining a deposit of silver chloride in the paper itself, which acquired a tolerably contrasty image during exposure in the camera obscura.

The question of retaining, or fixing, this paper image posed even greater problems. At first, Fox Talbot only succeeded in retarding the fading process of the silver nitrate but not in preventing it altogether, and he seemed to have come up against a barrier he could not overcome, at least for the time being. Parallel to his other work, he carried out experiments in shortening exposure times by alterations and improvements in his lenses, and eventually he was able to reduce the length of exposure to ten minutes in bright sunlight. He also experimented with Sir Humphry Davy's solar microscope, and in 1836 he succeeded in producing microphotographic paper prints 289 times the size of the original image.

Fox Talbot's experiments with his "sensitive papers" were by no means confined to work with the camera, for it was not long before it occurred to him to lay grasses, leaves, flowers, moss, and lace on sensitized paper in the darkroom and subsequently expose them to sunlight. By this means he obtained white silhouettes of the objects on a darker ground; he called these images "photogenic drawings," and although the photochemical basis was new, they may be regarded as a continuation of the activities begun by Leonardo da Vinci, which aimed at a method of reproducing natural objects by "mechanical" means instead of manual drawings. As far as printing and graphic techniques are concerned, these "nature prints" had already played a part from time to time in the illustration of scientific books in the form of *typographia naturalis,* in which leaves, flowers, and the like were rolled in ink and pressed onto the paper. Fox Talbot went a step further by delineating not only the outline and perhaps the plastic structure of the natural objects with his photogenic process but also the delicate gradations made visible by the greater or lesser degrees of transparency inherent in the subject—for example, a leaf. Since the photogenic drawings were negative, the final images were somewhat similar to X-rays.

It was not only the technical side of his photogenic images that interested Fox Talbot, and although he was a natural scientist by profession, his purely scientific involvement took second place to his primary urge, which was of an aesthetic nature. This is already evident from the title of the report he presented to the Royal Society in London in January 1839: "Some Account of the Art of Photogenic Drawing or the Process by Which Natural Objects May be Made to Delineate Themselves Without the Aid of the Artist's Pencil." Fox Talbot's method of producing images of natural objects on light-sensitive paper without the aid of a camera ushered in the development of a "photographic" technique which, although it was based on the photographic principle of the sensitivity of certain mediums to light—in this case sensitized paper—produced images that were really more closely allied to graphic art than to photography, and which employed a technique similar to that of the photogram.

Busy as he was with other areas of scientific research, Fox Talbot would probably not have carried on with his photographic experiments with such intensity if news of Daguerre's invention had not reached his ears. In an ambitious bid for priority, Fox Talbot managed to forge ahead with his research at the last minute with the help of his fellow countryman Sir John F. W. Herschel. On the one hand, he succeeded in shortening the exposure time necessary for his sensitive papers by employing a newly discovered "developer," and on the other, he achieved a greater degree of permanence in the developed image by the use of fixing salts discovered by Herschel.

But there was another aspect of Fox Talbot's work that was of still greater importance. Like all photo-experimenters, he had observed from the beginning that his photogenic images appeared "reversed"—that the light, or transparent, parts appeared dark, and the dark, or nontransparent, parts appeared light. This was especially striking in images made with the camera, in which the pictures were not only reversed as regards lightness and darkness but also "back to front"—left became right and vice versa. It did not take Fox Talbot long to realize that a reversal process was necessary in order to achieve "correct" pictures, and he reasoned that when the final, fixed image produced by light was reprinted, a second reversal of light and dark must result, thereby producing a "correct" picture. Herschel was the first to give the concepts of negative and positive their name, and the recognition of this principle, which later replaced that of the Daguerreotype, was one of Fox Talbot's most important insights that led him to the production of positive paper prints. Although his process was sometimes known as the Talbotype in the competitive battle with Daguerre, he himself called it the Calotype (from the Greek: *kalos* = beautiful), and through it he was able to make an unlimited number of positive prints from the negative of a single exposure—possibly his most important contribution to the history of photography. It had thus become possible to reproduce the photographic image, and the basic principle discovered by Fox Talbot has remained unchanged in spite of all subse-

quent developments such as the replacement of the negative paper by the wet plate and later by the dry plate and negative film.

Due to his standing as a natural scientist and scholar, and above all through the publication of his *The Pencil of Nature*, which appeared between 1844 and 1846, Fox Talbot succeeded in creating a respect for the new medium of photography from the very beginning, both as a means of objective documentation and of artistic creativity. He had proved the possibilities of photography not only through the imposing series of his enchanting photogenic drawings (plate 1) but also through his objective images of architecture, and still more through his simple, natural pictures of everyday life.

Fox Talbot was perhaps the first to develop an eye for the more modest aspects of our material environment: a broom leaning against a stable door; three men on a ladder working on a house façade; or a group of sailing boats in harbor (plate 2). What is more, he never attempted to incorporate elements of painting in his images, and his photographs always had a natural, unposed effect. This is particularly true of his numerous portraits in which his subjects hardly seem to have been aware of the photographer's presence, and they give the appearance of having been "apprehended" in natural positions and a natural atmosphere, engaged in natural activities (plate 3). It would appear that Fox Talbot, intelligent and cultured as he was and possessed of a typically English sense of understatement and horror of the theatrical, recognized that photography could only justify itself as a medium when its most valuable and unique quality, namely that of veracity, was employed to the full. This was due less to his personal inclinations and talents than to his specifically English character, and this also explains the fact that Daguerreotypy, as it had been introduced and cultivated in France, aroused no great enthusiasm in England—where it was used mainly for portraiture—whereas the concept of photography as an autonomous medium with its own intrinsic laws preached by Fox Talbot had a wide following in England from approximately 1850 onward.

Historical justice demands that mention be made of the photographers in France who struck out on their own, independent of Daguerre and his followers. The most important, and at the same time the most tragic, of them was HIPPOLYTE BAYARD (1801–1887) from Breteuil-sur-Noye in the Oise district of France. In complete ignorance of the activities of Nicéphore Niépce or Fox Talbot, Bayard somehow caught onto the ideas that seemed to be in the air at the time, and he was probably the first to discover possibilities leading to their realization. Artistic, highly talented, and eager for new fields of knowledge, he earned his living as a minor official in the Ministry of Finance in Paris, and together with a circle of contemporaries, lived in the free style which Murger later dubbed the "Bohemian way of life."

In 1838, Bayard began to take an intense interest in the seemingly absurd problem of the "use of light for the drawing of images produced by light itself." At the beginning of 1839, he had already succeeded in producing paper prints made in the darkroom subsequent to exposure. He called these pictures "photochemical drawings," and a few weeks after he had presented them to the scientist César Desprez, the whole of Paris knew about the innovation.

On May 20, 1839, Bayard presented his images, some of them made with the camera, to Dominique François Arago. Arago was not at all happy about Bayard's achievement since he had already invested far too much in Daguerre's still somewhat nebulous "invention," which he planned to present to the Academy—and thus to the French nation—in grand style in the near future. He therefore refused to admit that Bayard had succeeded in producing the first serviceable photographic pictures. His inborn modesty forbade Bayard to publicize his method of producing "light drawings" of old and picturesque corners of Montmartre, but he nevertheless told all his friends and acquaintances about it, and on June 25, 1839, he exhibited his photographic images in an exhibition in Paris. This was two months before Arago presented the famous report of Daguerre's invention, and it was the first time that photography had ever been shown in an exhibition. Bitter and disappointed though he was, Bayard refused to be put off, and he continued with his work, only to be pushed further and further to one side by Daguerre's growing and artificially nurtured fame. Bayard and his images were eventually completely forgotten, and although approximately 600 of his pictures have been preserved, it is only recently that he has been rediscovered and has achieved a measure of recognition.

Bayard's process consisted of the preparation of papers with silver chloride, and this resulted in direct positive images subsequent to exposure. Later on, Bayard sometimes used the Talbot negative-positive process, especially during the years of his partnership with the photographer Bertall. It is interesting to note that Bayard, like Fox Talbot, also produced photogenic images—photograms—without the use of a camera during the early stages of his experiments with "light drawings." One of the finest of these is a combination of bird feathers, a piece of checked material, and a reproduction of an etching—a montage that bears witness to his sure artistic instinct and flair for composition, and which anticipated similar experiments made nearly 80 years later (plate 4). Apart from the pictures of people, usually taken out-of-doors in gardens or backyards, his still-lifes are particularly remarkable—highly individual arrangements of everyday and art objects,

enigmatic juxtapositions whose obscure "be-ing" radiates a mysterious poetry (plate 5). The pictures seem to possess a secret life of their own, and they pose more questions than they answer.

Bayard provided an almost macabre answer to the lack of recognition of his achievements in 1840 in the form of a photographic self-portrait in which his naked corpse is depicted seated on a chair. The text on the back of the photograph reads: "The mortal remains you are now looking at are those of Mr. Bayard, inventor of the process which you have just seen, or the wonders of which you are about to witness. As far as I know, this inventive and tireless researcher has been busy with the perfection of his invention for the past three years . . . The government, which supports Mr. Daguerre far more than necessary, declared itself unable to do anything for Mr. Bayard, and the unhappy man therefore drowned himself in despair . . . Artists, scientists, and journalists were interested in him for some time, but although he has now been in the morgue for several days, no one has yet recognized him, not to speak of noticing his absence . . . Ladies and gentlemen, let us proceed to a more pleasant topic, in order to avoid offending your sense of smell; for as you no doubt will have already noticed, Mr. Bayard's hands and face have begun already to decay."

This unique document bears witness not only to Bayard's grim sense of humor but also to his recognition of his position as a pioneer of photography. Unfortunately, however, this knowledge was not shared by others, and he was to remain unrecognized long after his death.

Whereas Daguerreotypy made only a limited, and above all temporary, impact in England, Fox Talbot's Calotype process had a large and extremely successful group of followers. It would appear that the Victorians regarded the incorruptible medium of photography, and above all the "photographic style" inaugurated by Fox Talbot—an objective, simple, faithful, often almost rigid, puritanical, and completely untheatrical representation of people and their environment—as an authentic expression of their era.

The London World Exhibition of 1851 had a determining influence on the medium's development, for not only was it an important subject for young photographers, it also provided (to quote Philip James's appraisal of Victorian photography) "an impetus to the new art. Amateurs from all over England were brought into contact with the work of other photographers, and the exchange of ideas and practical methods, combined with the epoch-making invention of the wet-plate process, had a mighty influence on English photography in the years which followed." In the exhibition itself, photography was classified as a scientific, and not as an artistic, medium, and although this may have retarded the re-

cognition of the creative qualities of the medium and overemphasized its scientific aspects, the work of Victorian photographers nevertheless shows that —consciously or instinctively—they recognized the creative possibilities of photography, as well as its latent ability to depict the essential being of man, which lies behind the outward appearance.

Among the many English photographers of the time, whose discovery or rediscovery is due largely to the work of the researchers and collectors Helmut and Alison Gernsheim, a few personalities stand out clearly. Apart from Roger Fenton, Thomas Keith, James Robertson, Henry Peach Robinson, and Charles Lutwidge Dodgson (who was well known as the writer of *Alice in Wonderland* under the name of Lewis Carroll), and many others, the greatest influence on this new English photography was exercised by David Octavius Hill and Robert Adamson, as well as by Julia Margaret Cameron.

The Scotsman DAVID OCTAVIUS HILL (1802–1870) came to photography from landscape painting through a mixture of chance and expediency. In 1843, he was commissioned to paint a huge picture of the 474 founders of the Free Church of Scotland, and he was thus faced with the impossibility of painting true likenesses of all the persons depicted from memory. Sir David Brewster acquainted him with the portrait photographs made by the process invented by his friend Fox Talbot, and since Hill knew nothing about photography, he engaged the services of the Calotypist ROBERT ADAMSON (1821–1848) who lived in Edinburgh and who had already proved his ability as a photographer in his independent work. A fruitful collaboration between the two arose, which did not end with the quick production of the 474 portraits for Hill's monumental painting. Hill and Adamson went on to make an enormous number of photographs together in which the emphasis lay on portraits of the Scottish society (plate 8), but which also included countless folk scenes, particularly of the life of Scottish fishermen, as well as pictures of Scottish architecture and villages. Remarkably, although Hill was primarily a landscape painter, only a few of his paintings have been preserved.

It is difficult to distinguish the two partners in the joint work of approximately 1,500 photographs. It is, however, a revealing fact that Hill gave up photography after Adamson's early death in 1848 and subsequently turned his full attention to painting, without achieving any remarkable results. Basically, it was probably Adamson who carried out the technical work, and Hill may have felt helpless without his astonishing skill. Hill himself must have judged photography by the criterion of its pictorial possibilities; and he must also have had the gift of explaining his concept—born of his knowledge of drawing and painting and of the conversion of color into the tonal values of the Calotype—convincingly to his

partner. The strength of their photographs lies primarily in the often unusual choice of angle, the sometimes surprising cropping, subtle distribution of light and shade, the rich play of delicate or violent transitions from light to dark, and finally in the photographers' evident interest in the quality of their work. All these factors combined to make at least a part of the work of these two Scotsmen take its place among the first "master works of photography."

What was the secret of Hill's mastery? Had a photographer who worked with Hill been asked this question, he might have replied as follows: "It is certainly not his technical skill but rather his ability to express himself in spite of his limited technique. He possesses an artistic imagination of unusual proportions, a masterly sense of form, and a sure instinct for clear and simple composition." To this might be added that Hill also had a feeling for the unusual and even the fantastic. When he juxtaposed himself or other models with plaster casts of classical sculpture, this was not merely a theatrical effect but an expressive, impactful confrontation (plate 6). And when, as was often the case, he took his models to Greyfriars Cemetery in Edinburgh, it was not in the interests of a sentimental effect but an endeavor to find a new way of portraying the ancient theme of transitoriness, and to create a natural confrontation of life and death (plate 7).

The most outstanding of the English Victorian photographers was undoubtedly JULIA MARGARET CAMERON (1815–1879). An unusual example of the "English eccentric" prevalent in England at the time, Lady Cameron, wife of a member of the Indian government, had already proved her talents and ability in several other fields before turning to photography for her own personal pleasure. Using a converted coal cellar as a darkroom and a henhouse fitted with large panels of glass as a studio, she made a thriving business out of small-format portraits in the style of Adolphe Eugène Disdéris's "cartes de visite." Particularly important was her choice of a camera for large-format glass plates (approximately 11¾" × 15¾"), and she was the first photographer to concentrate on what later became known as the "close-up" in the field of film-making.

Since Lady Cameron was not obliged to earn her living by photography, which she incidentally regarded as a "divine art," she was at liberty to photograph how and when she pleased. With a sovereign disrespect for convention and a supreme disregard for the generally accepted way of doing things, she felt free to follow her own instincts and inclinations. Thus she was even able to do without the use of "props" and requisites in her portraits and concentrate the whole of her intelligence and psychological perception on the essential character of her sitter. The result of her endeavors was an impressive series of fascinating portrait studies, most of them taken in the 1860's, of great personalities seen through the eyes of another great personality.

Julia Margaret Cameron had one curious weakness. Through the influence of her many friends, and particularly of the poet Alfred, Lord Tennyson, her attention was constantly drawn to the importance of poetry as an art, and this tempted her to venture into an area of creative activity we might call "literary photography." The result was an almost farcical, eccentric, and sometimes highly sentimental kind of genre photography, which formed a well-nigh incomprehensible contrast to the expressive impact of her portraits. Her illustrations and interpretations of works by Shakespeare, Tennyson, and Lewis Carroll reflect the bloodless art of the Pre-Raphaelites, and in many cases they verge on the ridiculous. Her allegorical photographs do, however, provide us with a glimpse into the way of thinking of the literary and artistic elite society of the Victorian era; in addition, they reflect—far more clearly than the more usual contemporary genre photography based on salon painting—the exaggerated literary and even spiritualistic artistic trend which, unpalatable as it is to the modern viewer, nevertheless reveals hidden references to the surrealist intellectual climate (plates 11 and 12).

Julia Margaret Cameron was by no means alone in practicing this artificial photography so far removed from the veracity of the true nature of the medium, and she was even excelled by some of her contemporaries. One of these was the Swedish painter OSCAR GUSTAVE REJLANDER (1813–1875) who moved to England and turned to photography following art studies in Rome. Like a number of other painters, he was primarily interested in photography as an aid to painting, but it was not long before he established himself as a professional photographer in Wolverhampton, and five years later, in 1860, he opened a commercial studio in London. Rejlander has the doubtful distinction of being the main representative, and perhaps even the initiator, of allegorical photography. Although he started by photographing the posed models and groups of figures usual at the time, which were easily "arranged" in front of the camera, it was not long before he turned his attention to more demanding tasks that posed some problems for the troublesome and somewhat limited picture-making techniques of the time.

In a spirit reminiscent of the sign bearing the proud words "The Temple of Art," which hung over the shop of the New York photographer Charles D. Fredrick in 1852, Rejlander dreamed up compositions loaded with allegorical meanings, which he realized by means of the separate exposure of single scenes and figures subsequently combined to form a kind of photomontage. His main work in this "art photography" style was the allegory entitled "The Two Ways of Life" which, composed of 37 single images, measured 30¾" × 15¾" and caused a sensation in an art exhibition in Manchester in 1857. The

William Henry Fox Talbot

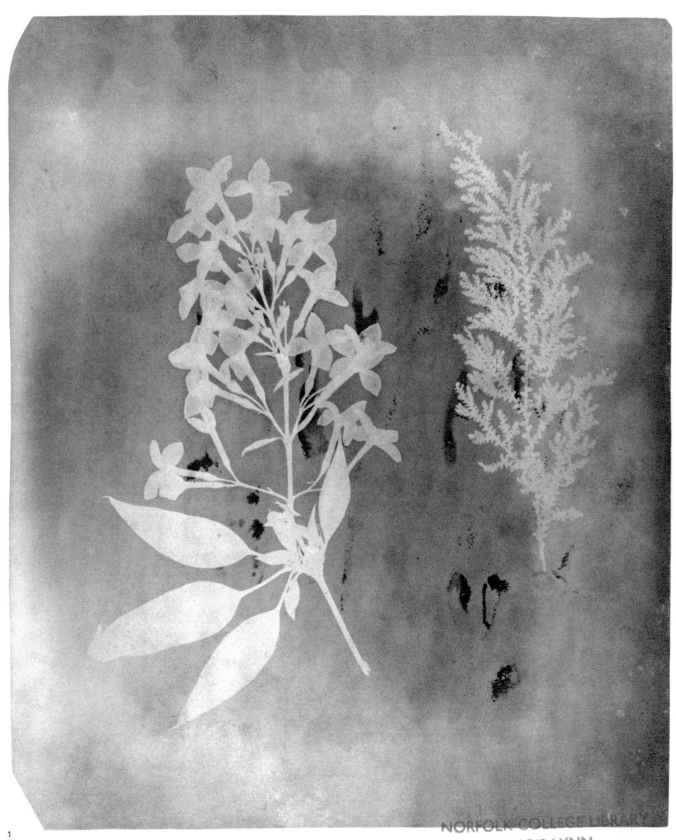

1

William Henry Fox Talbot

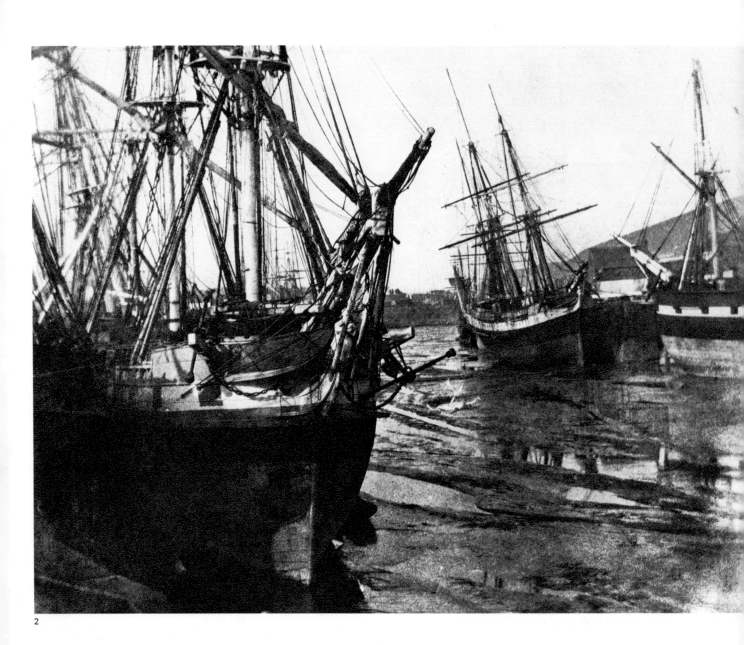

2

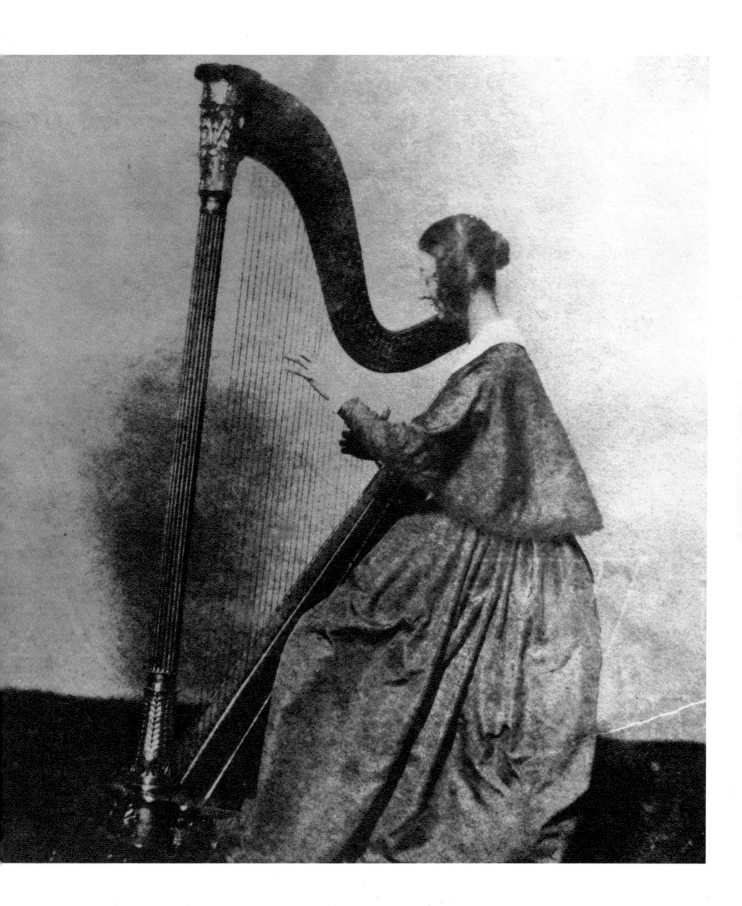

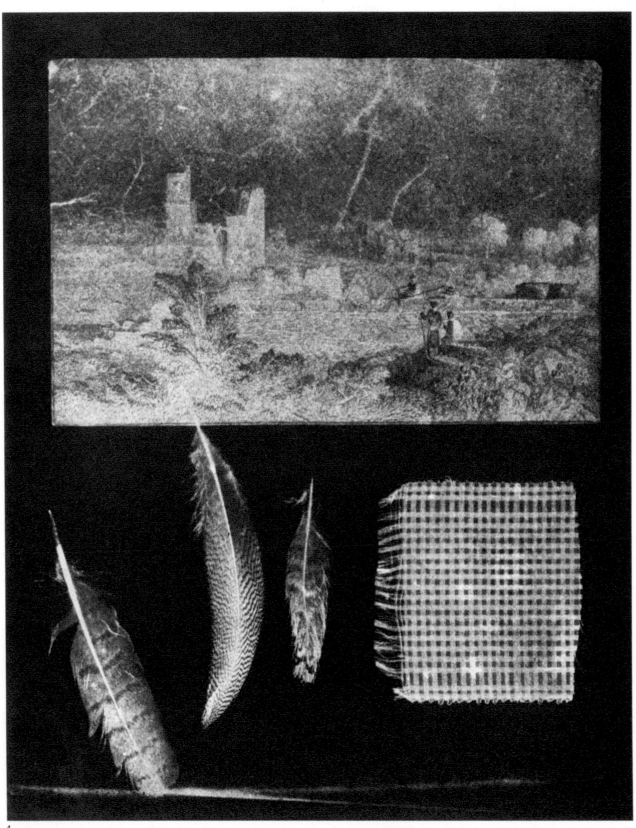

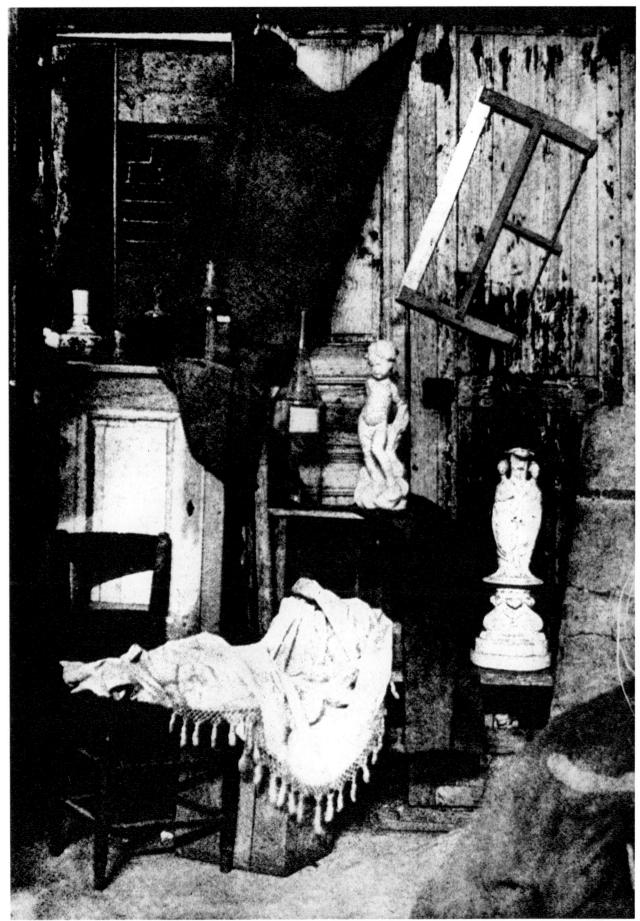

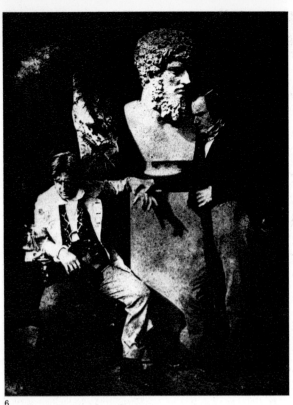

6

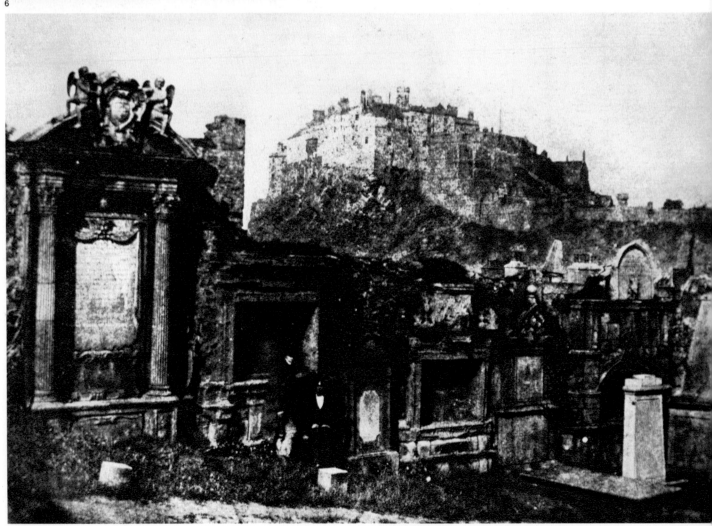

7

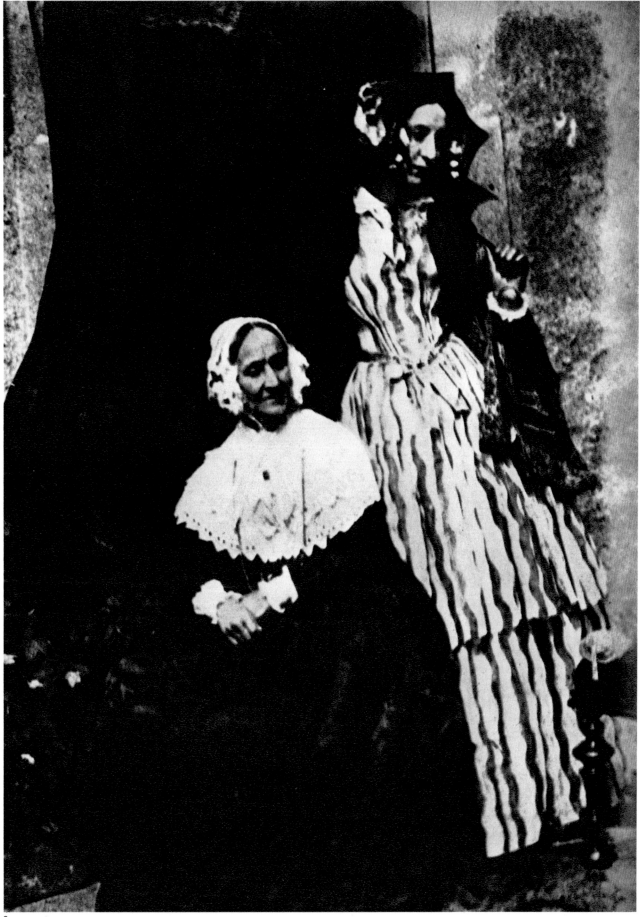

Oscar Gustave Rejlander

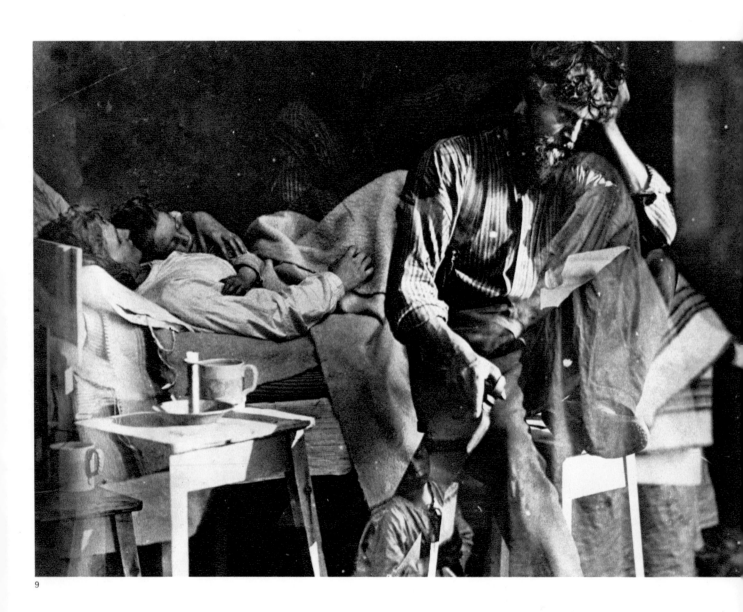

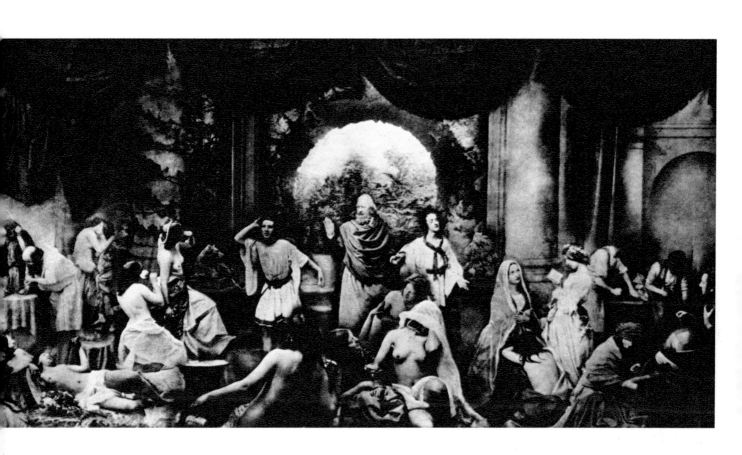

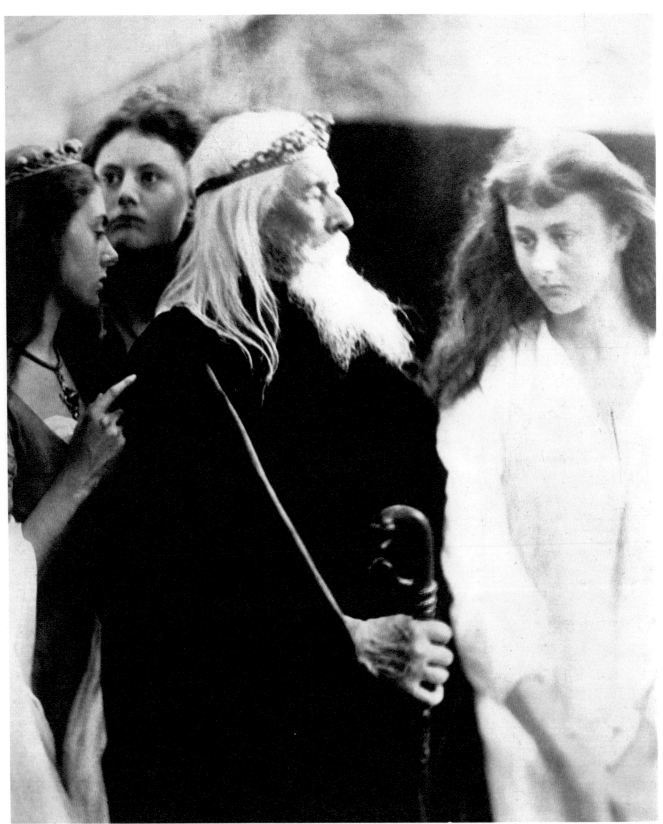

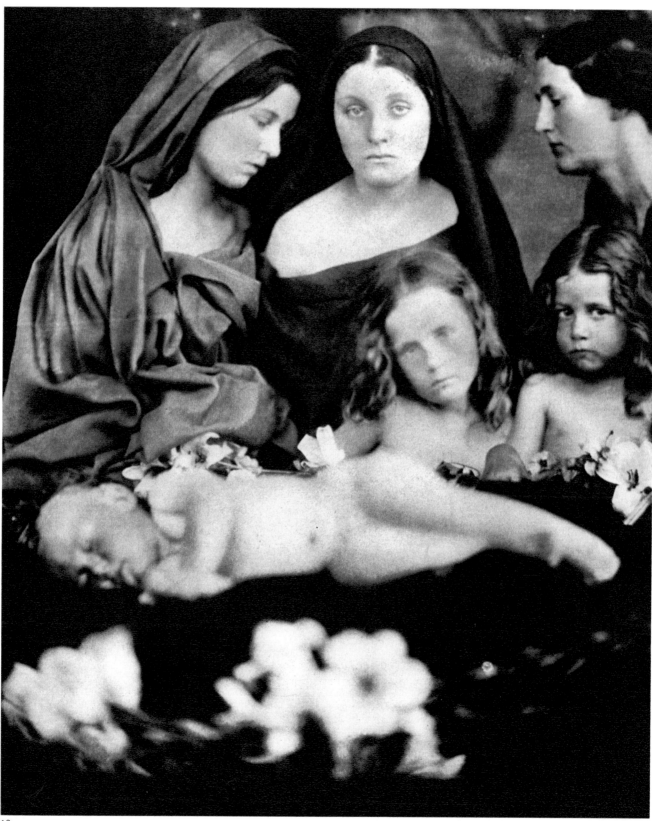

Henri Le Secq

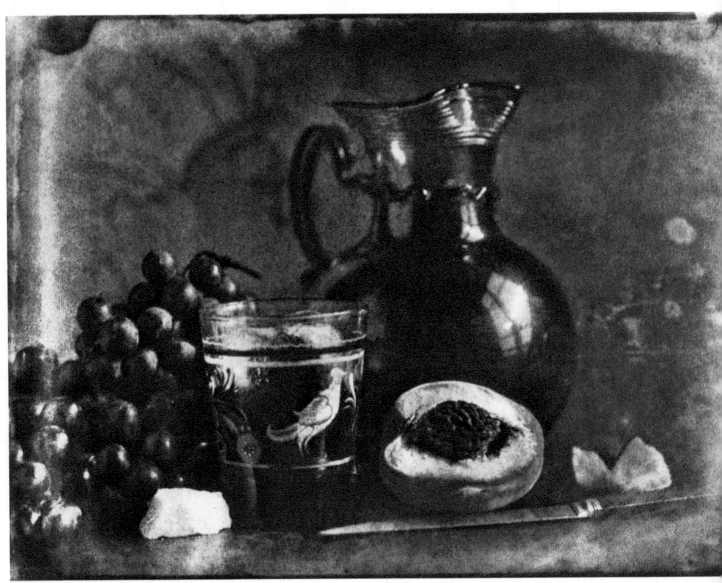

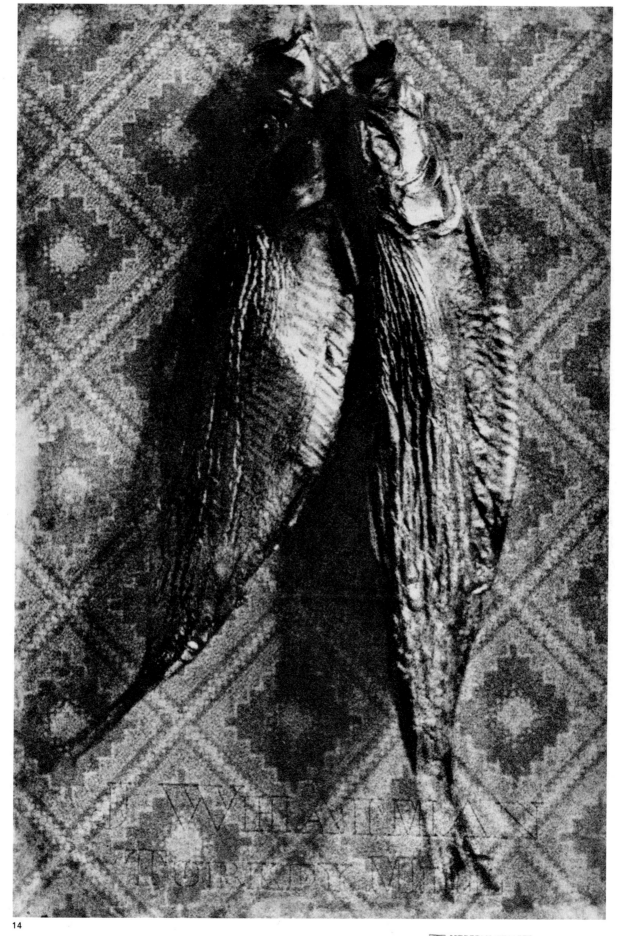

14

Henry Peach Robinson

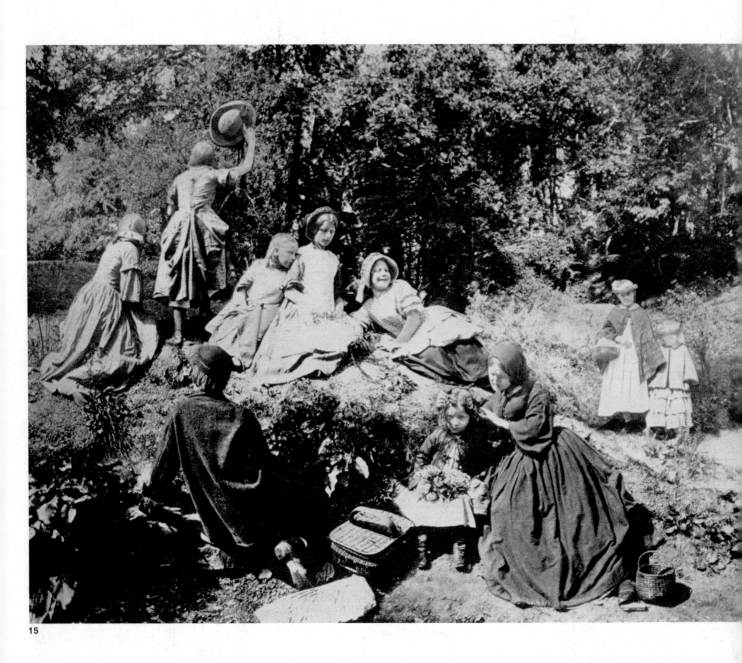

15

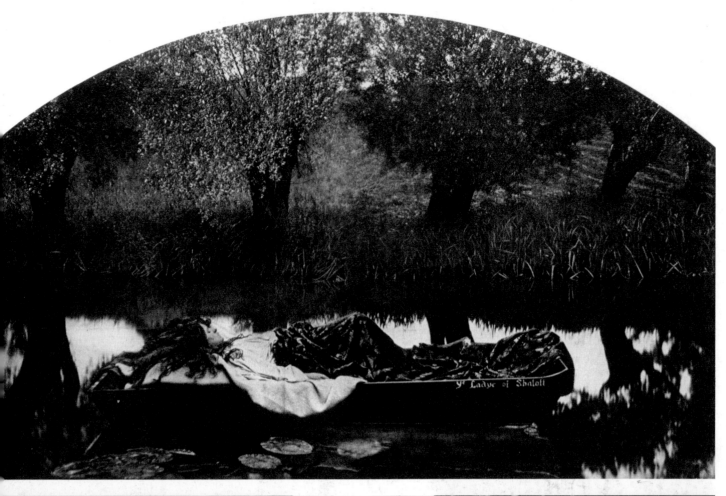

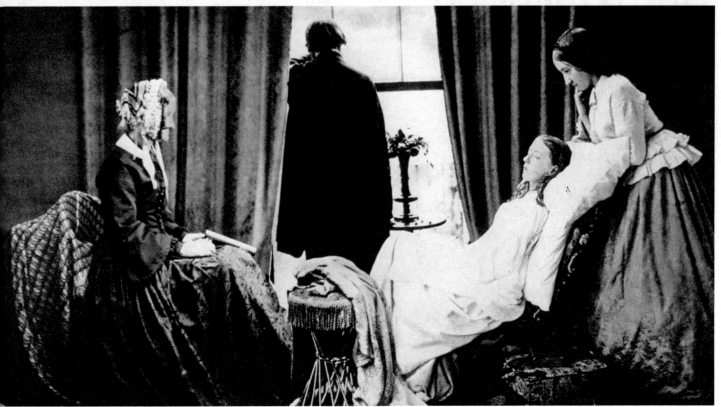

Camille-Baptiste Corot

Charles François Daubigny

Théodore Rousseau

Jean François Millet

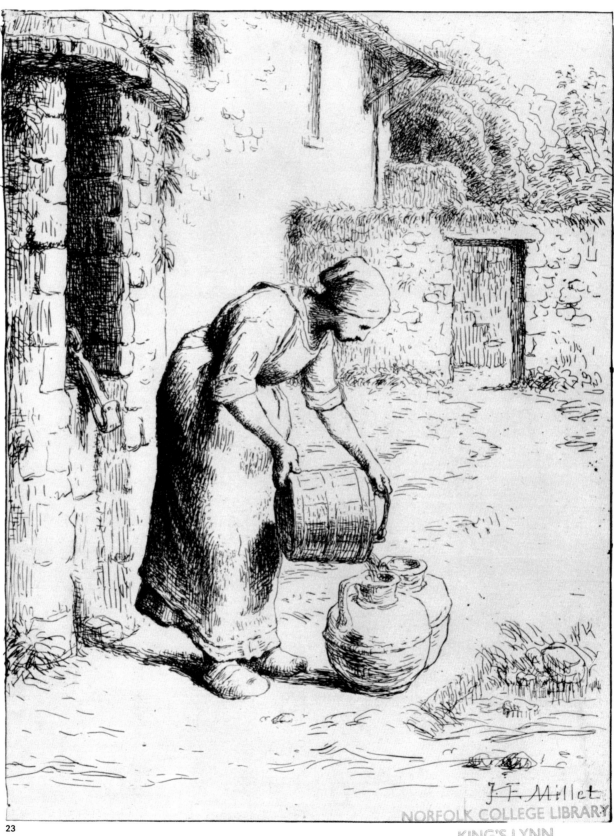

J.F. Millet

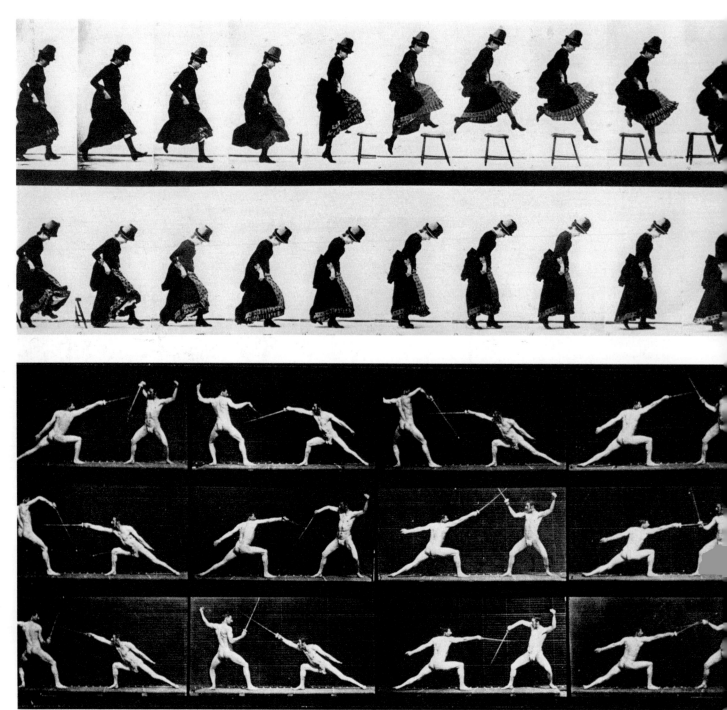

Etienne Jules Marey

25

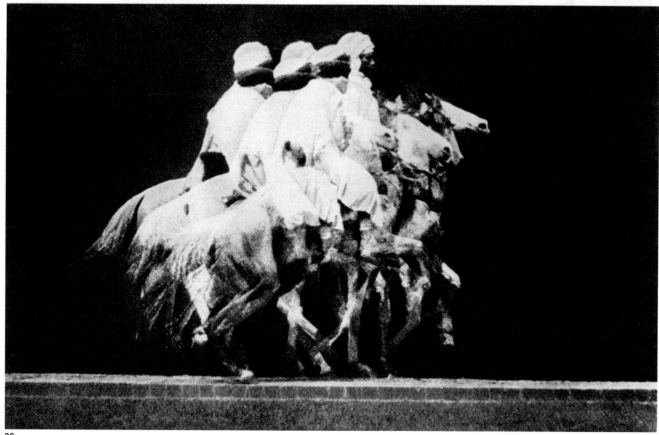

26

27

28

29

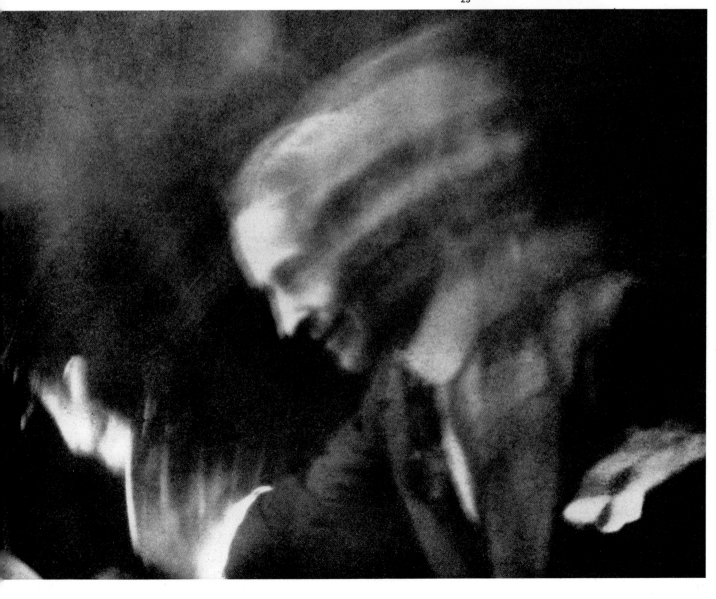

Anton Giulio Bragaglia

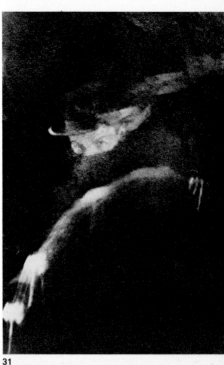

31

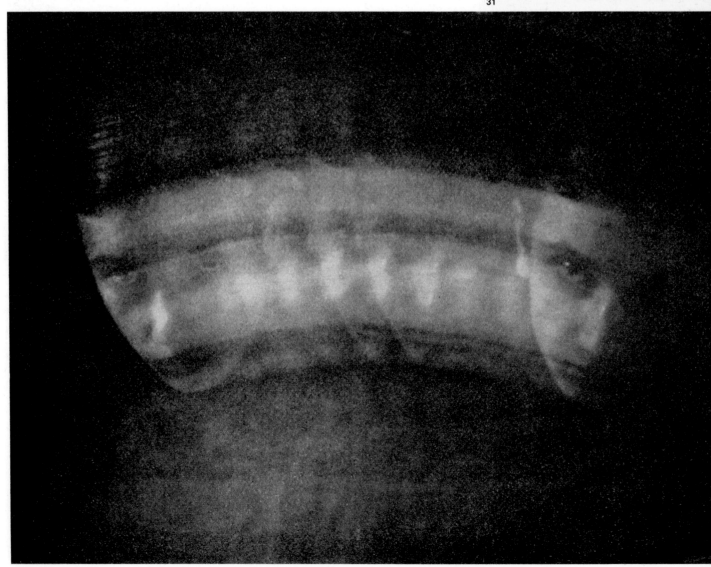

32

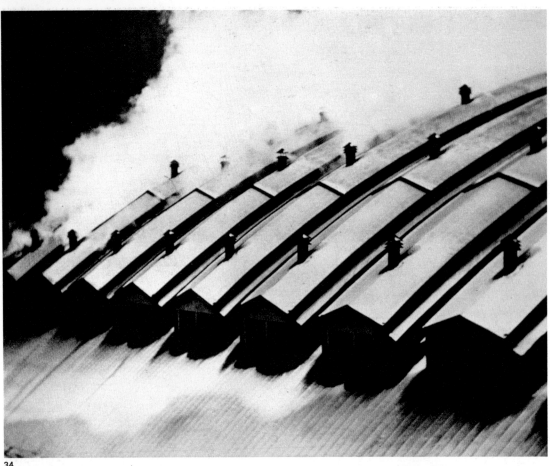

34

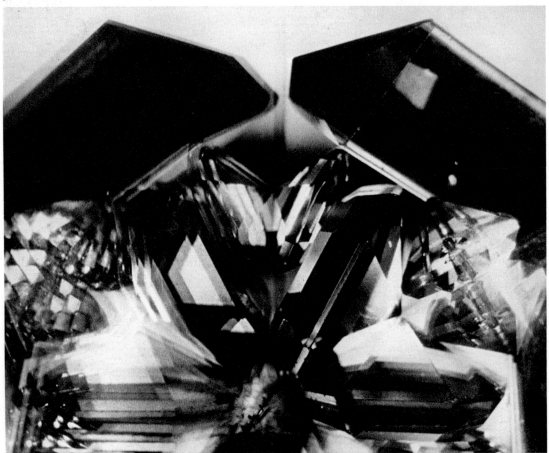

35

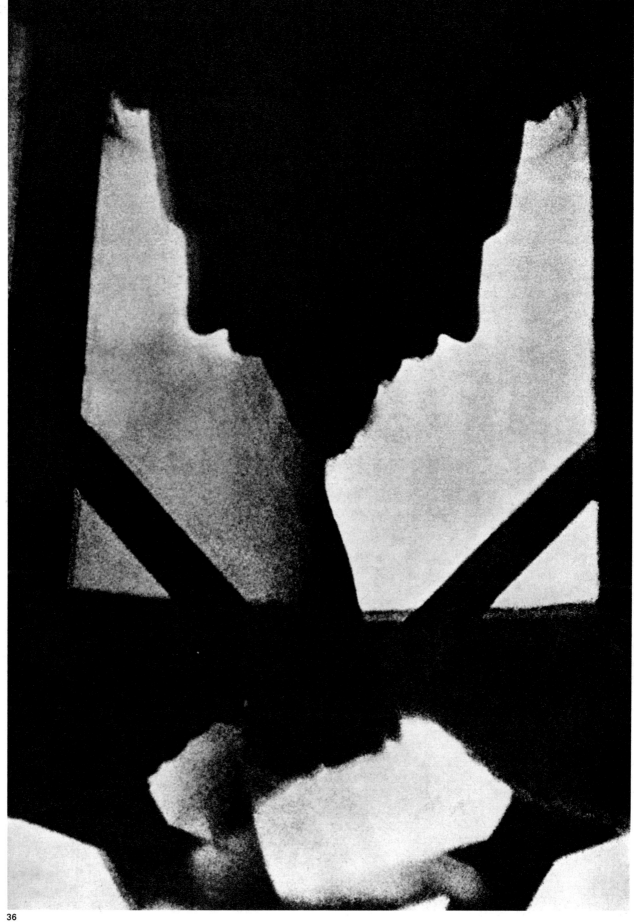

Christian Schad

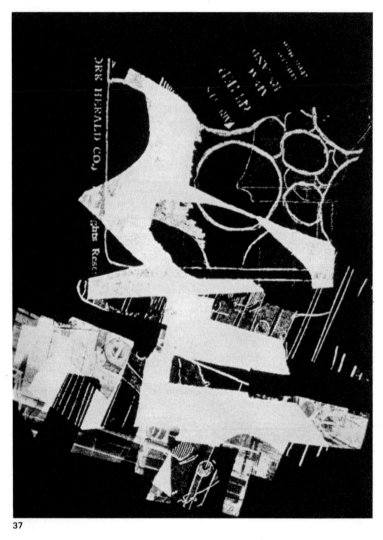

37

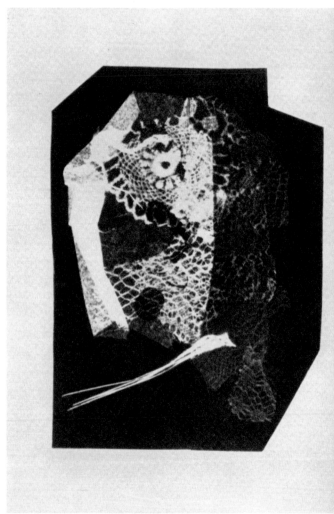

38

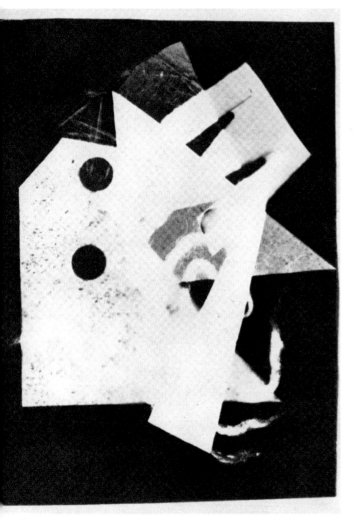 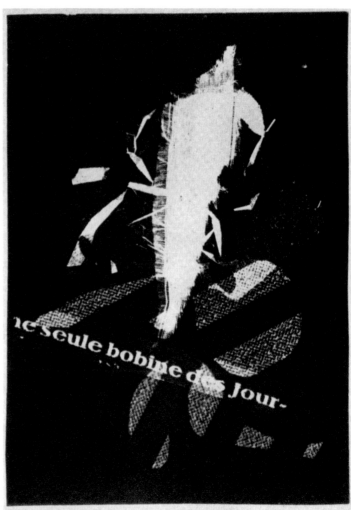

40

Raoul Hausmann

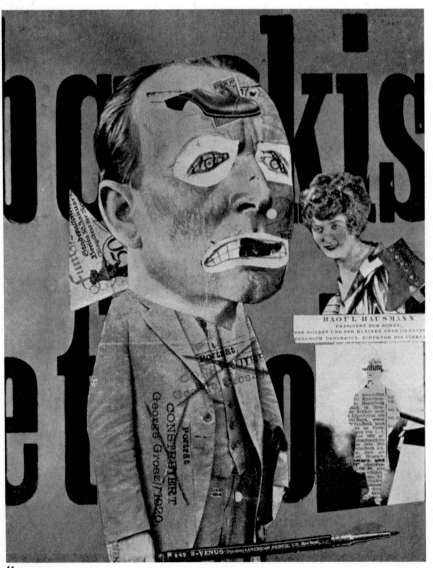

41

42

43

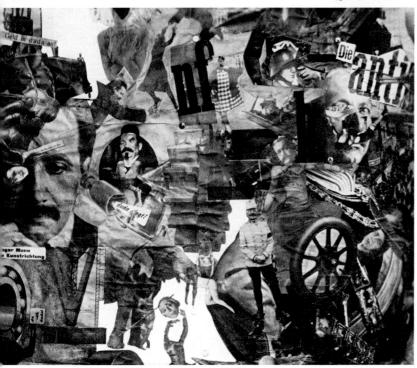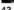

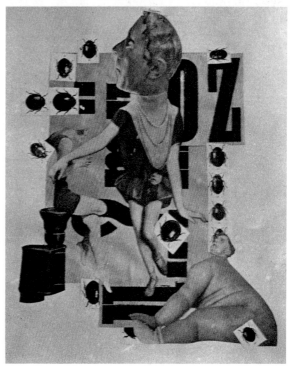

45

Hannah Höch

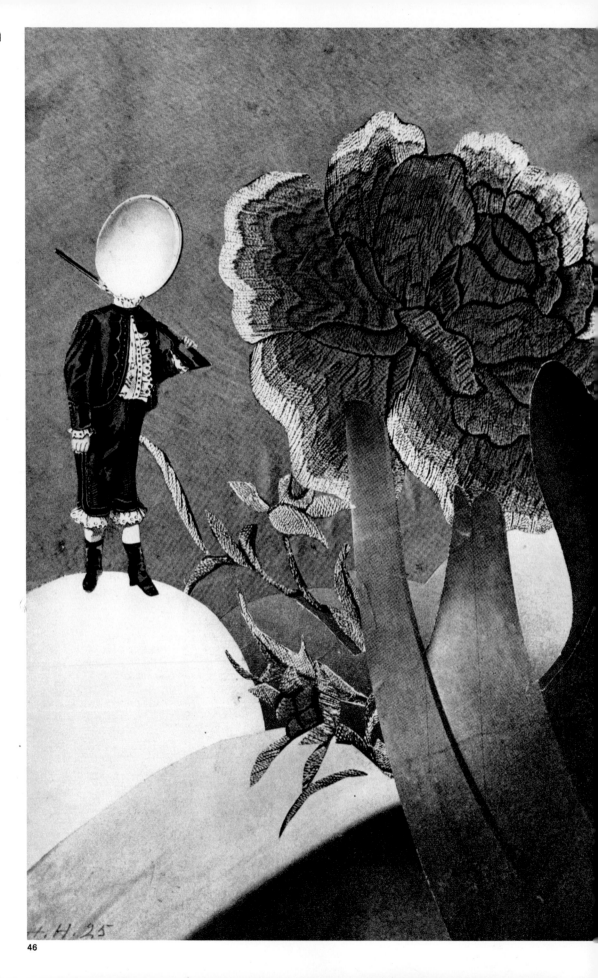

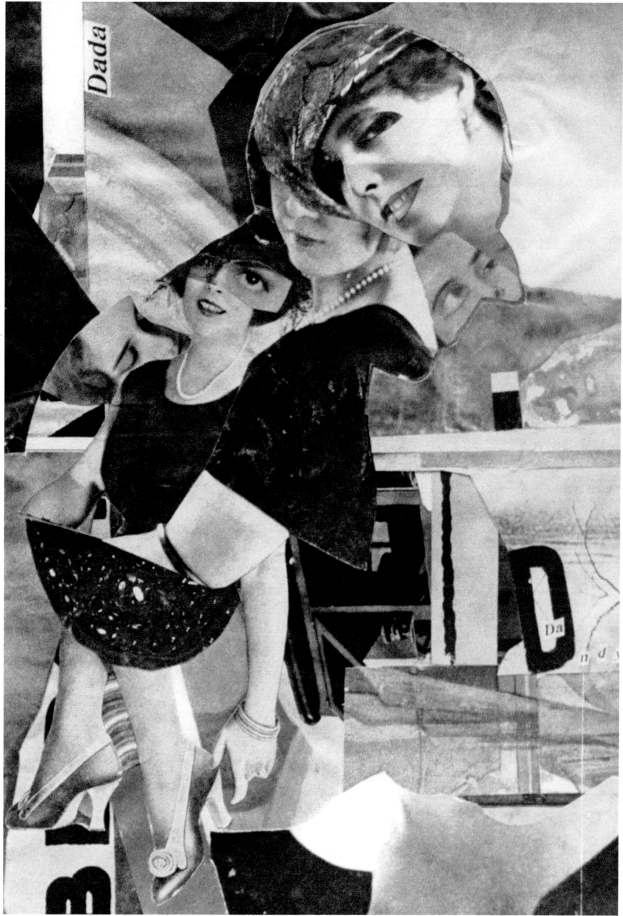

Man Ray

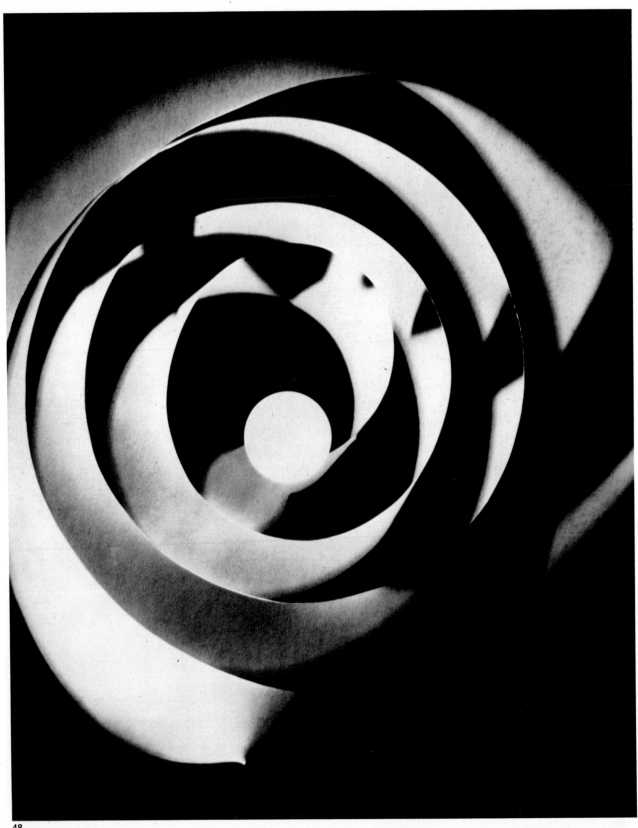

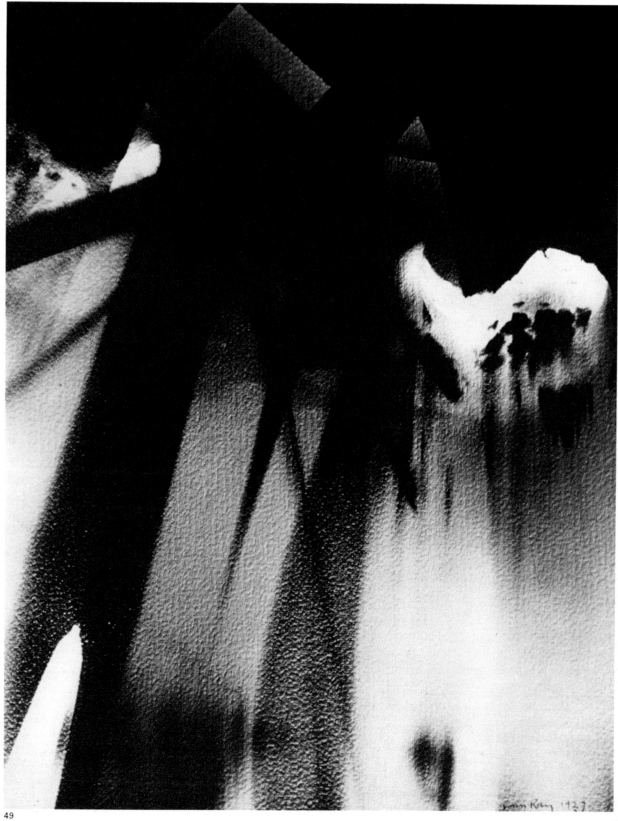

Man Ray

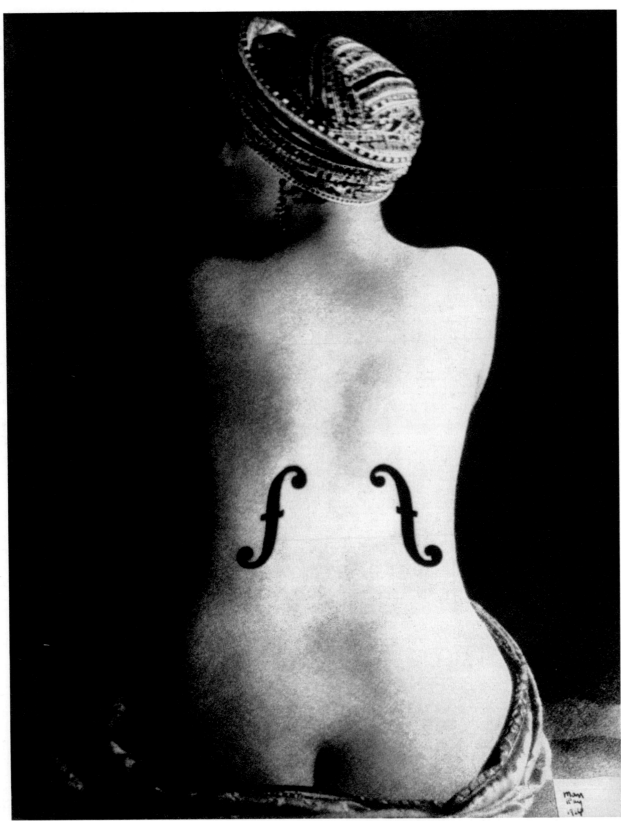

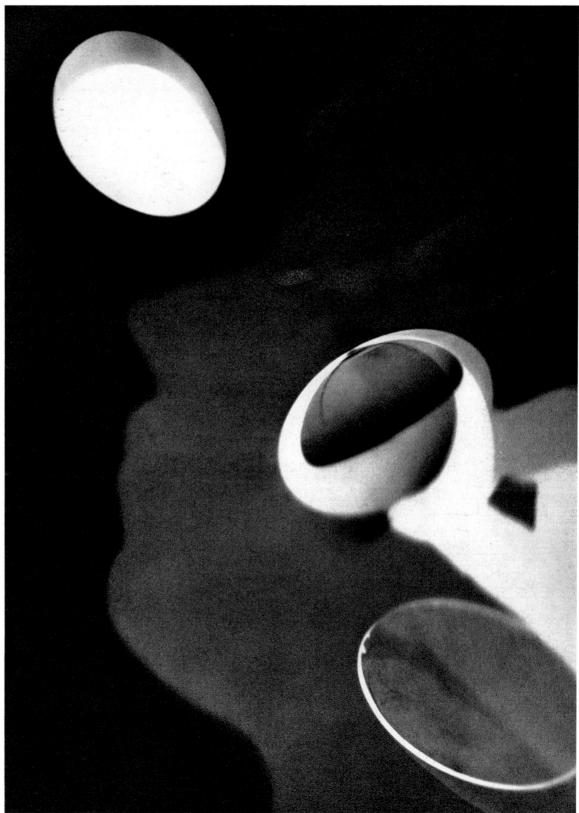

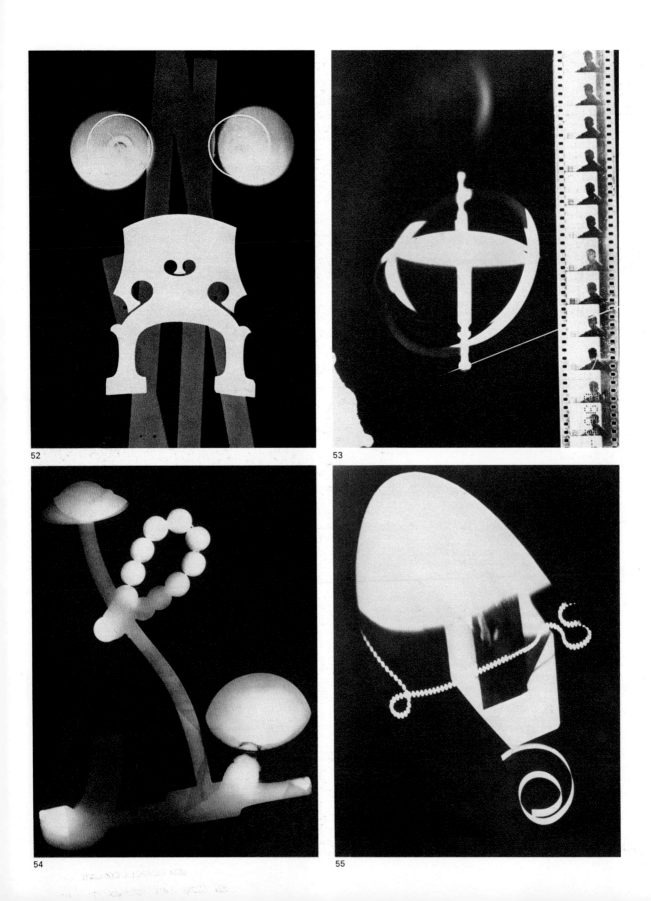

52

53

54

55

John Heartfield

57

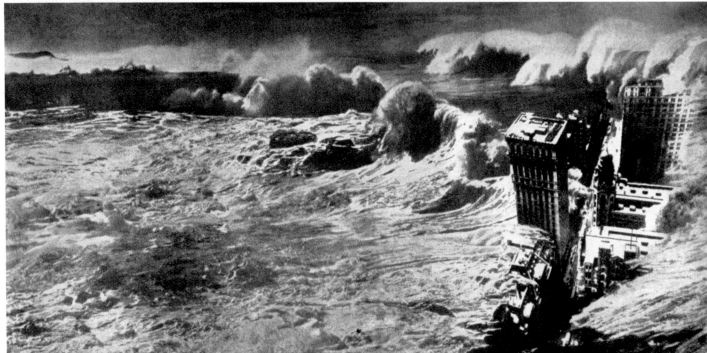

58

59

60

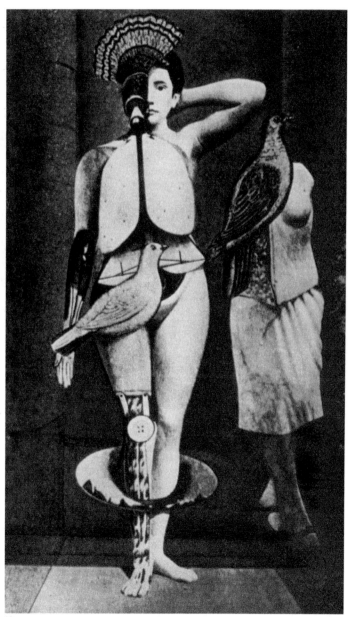

Lászlò Moholy-Nagy

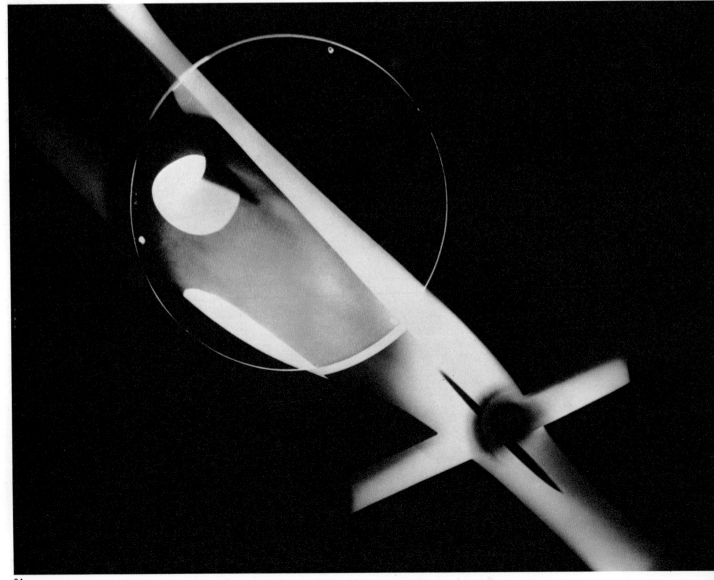

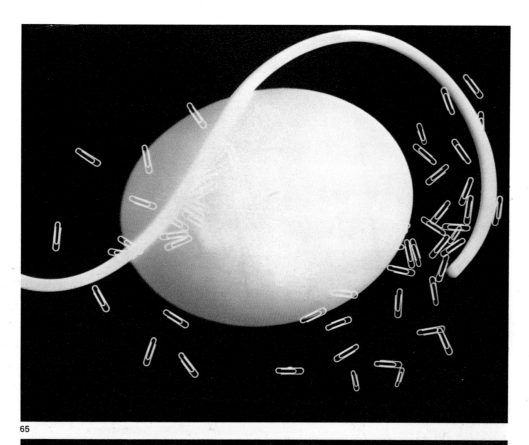

65

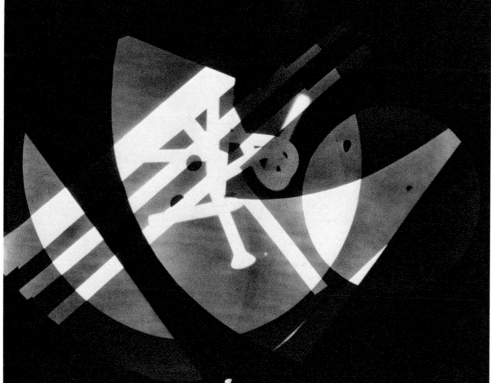

66

László Moholy-Nagy

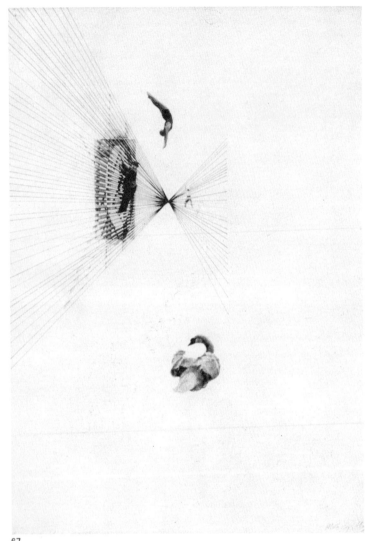

67

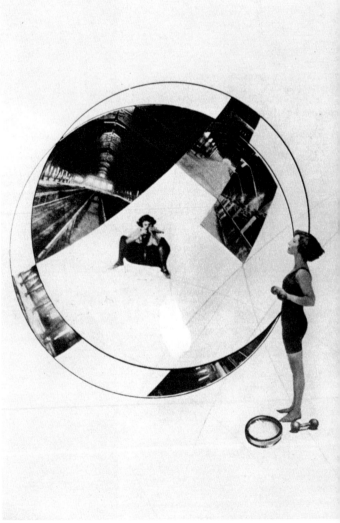

68

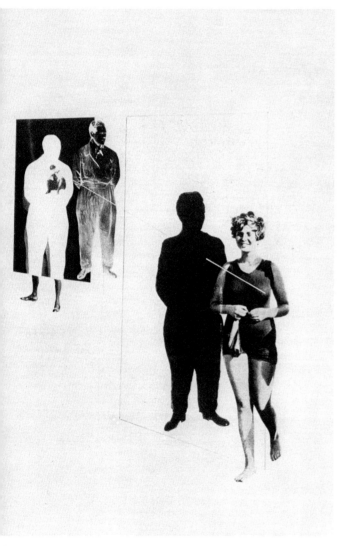

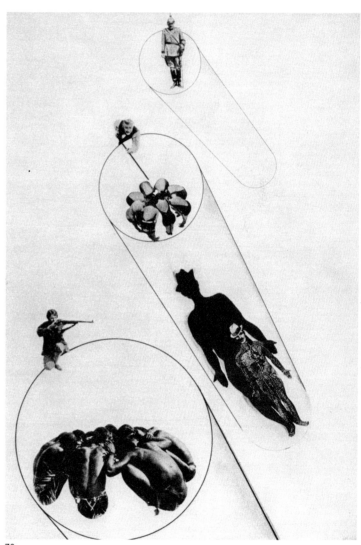

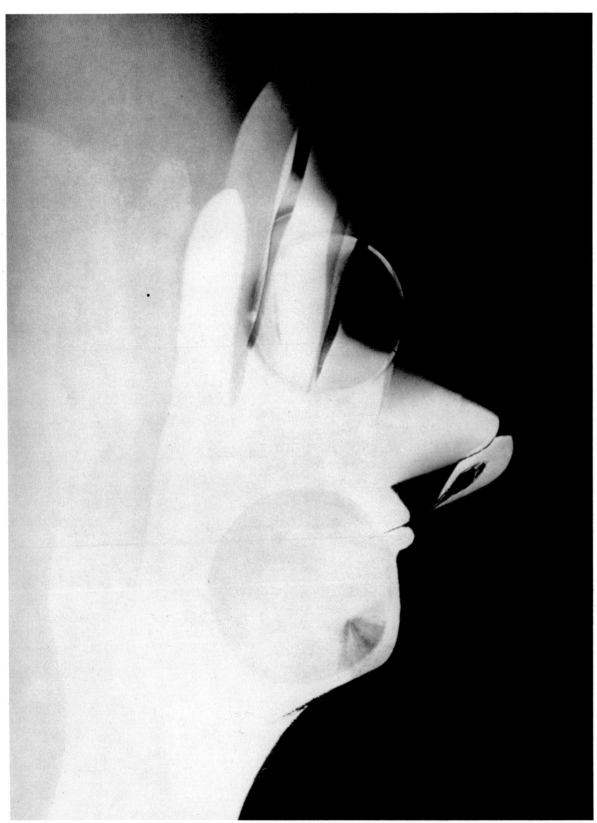

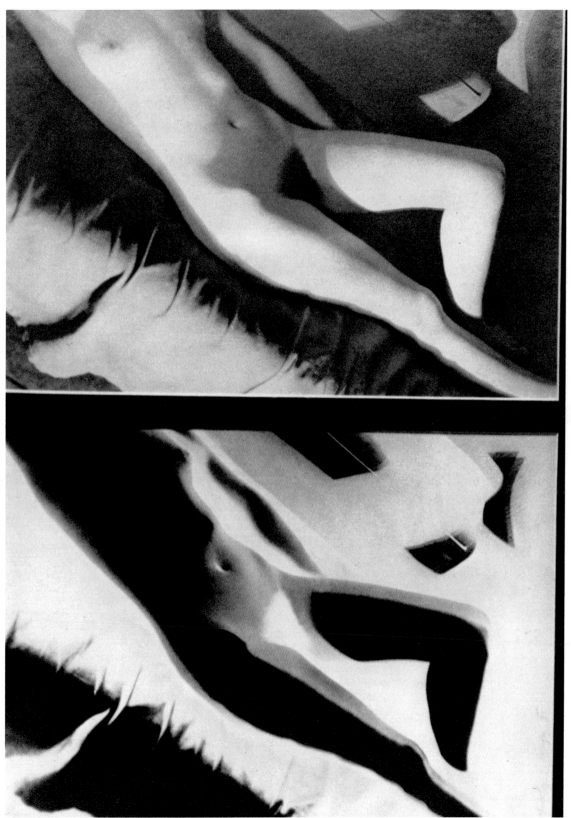

Herbert Bayer

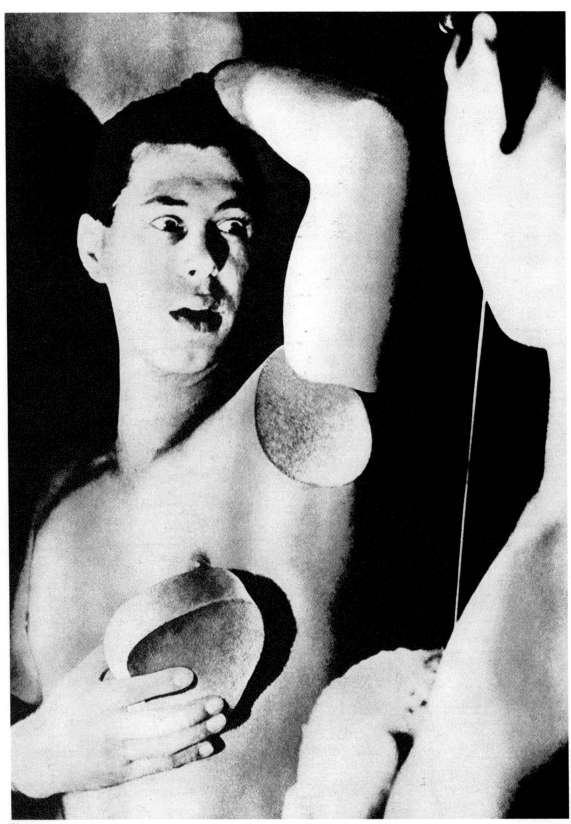

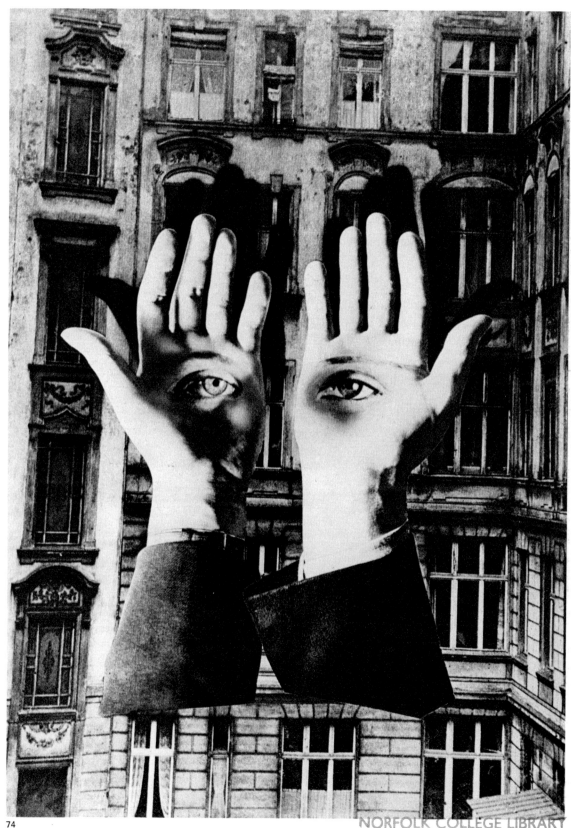

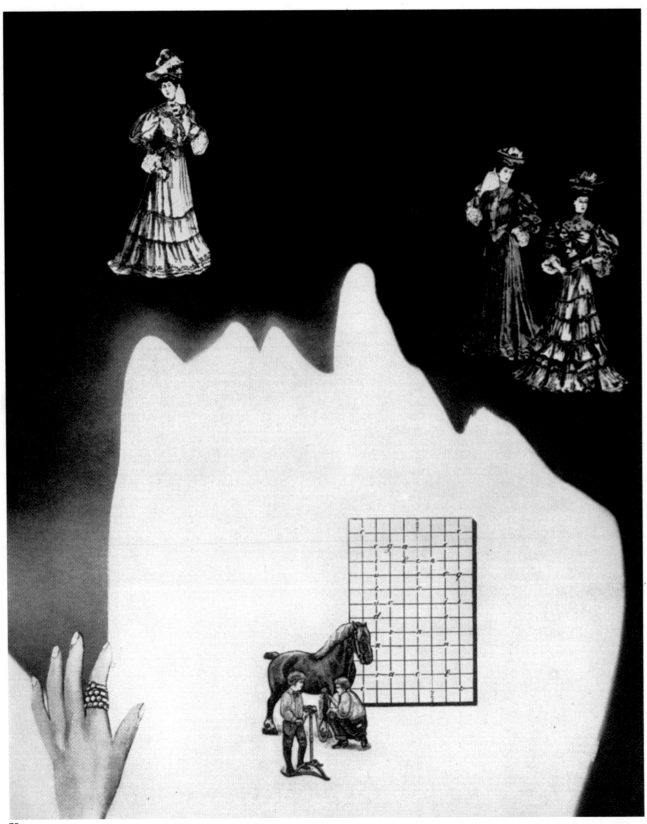

Frank

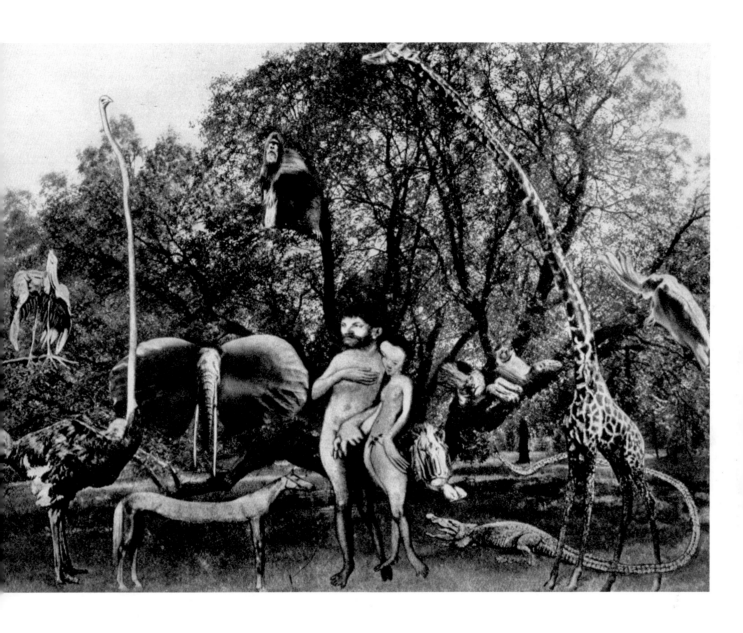

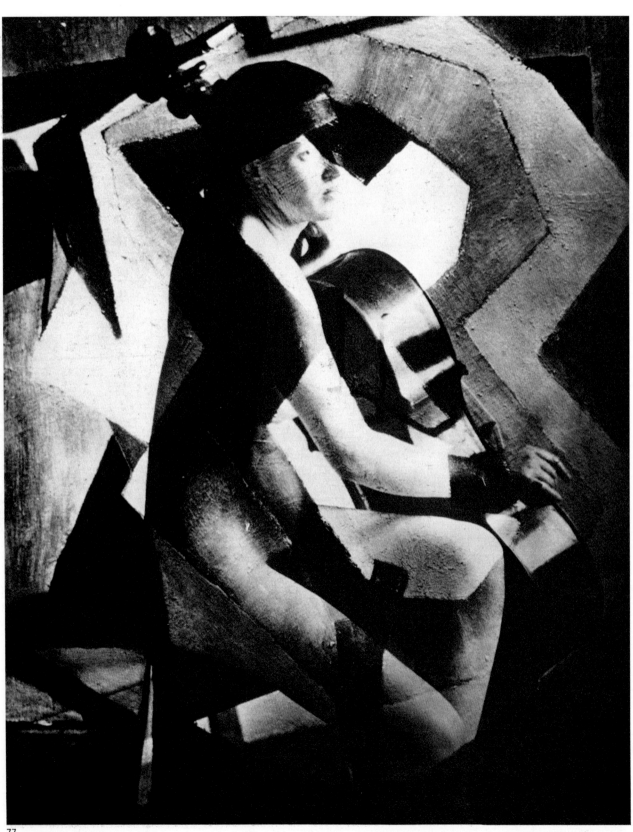

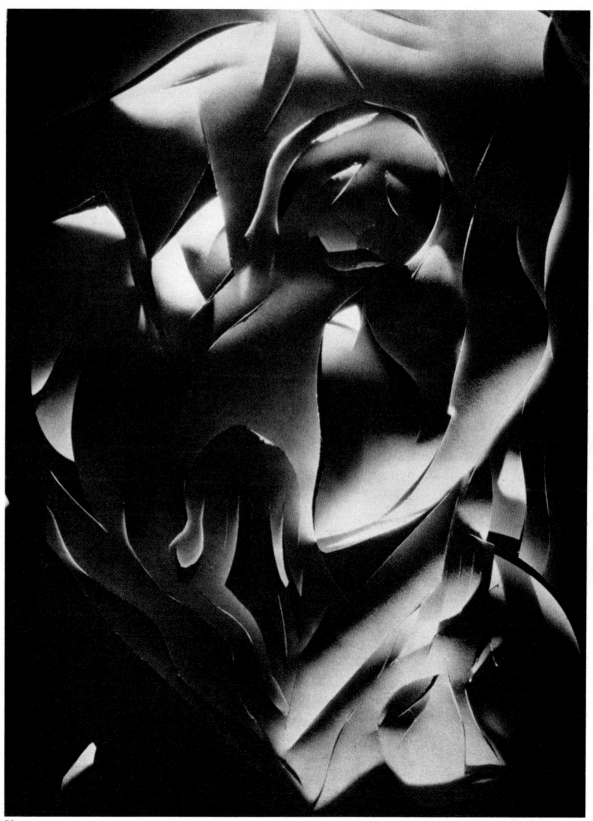

78

Francis Bruguière

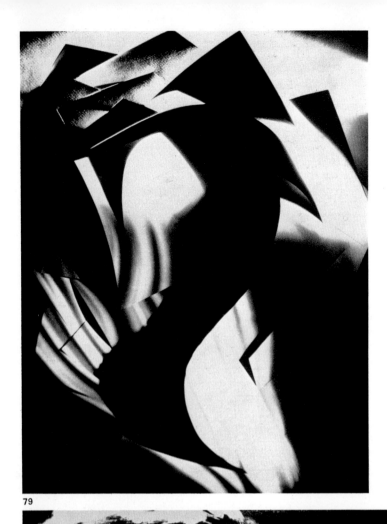

79

80

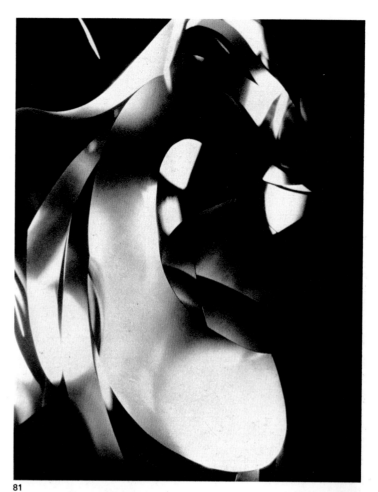

81

82

Paul Citroën

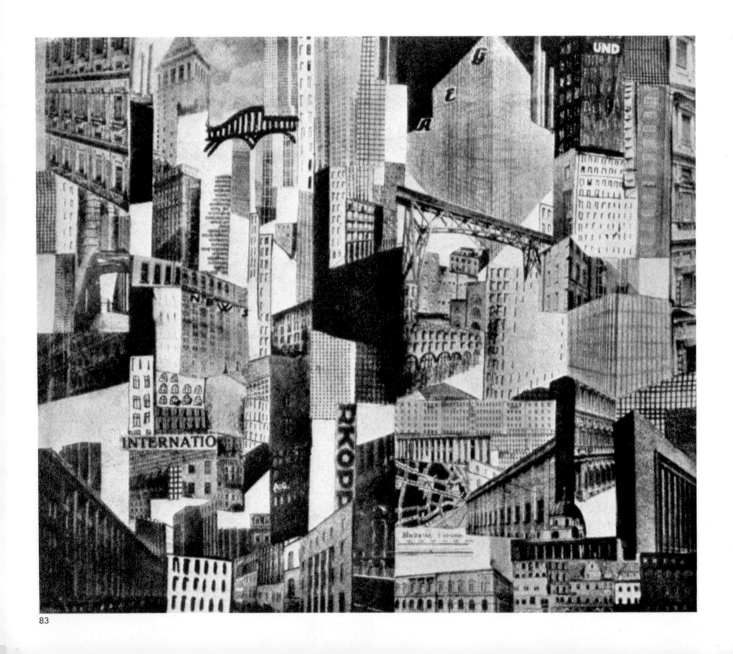

scene depicts a sage initiating two young men into adult life, one of them occupied with religion, charity, diligence, philosophy, and other virtuous activities, the other with worldly pleasures such as gambling, wine, sexual excesses, and other vices. The center of the foreground is occupied by the allegory of "remorse and the symbol of hope" (plate 10). Neither Rejlander nor the literary photographers really succeeded in making their mark with scenes of this kind which, like the historical paintings of the time, probably corresponded to but failed to anticipate the taste of the period. In addition, genuinely photographic portrayals of people and things were now becoming widespread, particularly in England.

More interesting from the artistic point of view are Rejlander's experiments in printing several specially made images together to form photomontages with specific atmosphere and mood (plate 9). These pictures sometimes seem to be representing different stages of a single movement superimposed upon each other, and as such would appear to take their place among the early attempts at a comprehension of the phenomenon of motion by photographic means. On the other hand, they have a specifically imaginative and fantastic character, and were intended as penetrations or superimpositions of different and dissimilar levels of reality. Due to the use of the photographic medium, these photomontages are both realistic and irritatingly unrealistic, and some of them are reminiscent of lithographs by Odilon Redon, as well as of surrealist compositions such as the early woodcut collages of Max Ernst. The somewhat exaggerated studies in human expressions, which Rejlander made as illustrations for a publication by Charles Darwin, also have a prophetic quality.

Rejlander was not the only exponent of this staged "art photography," and he had a real competitor in another deserter from the field of painting, HENRY PEACH ROBINSON (1830–1901), who turned to photography in 1857 and whose lightning success earned him the doubtful distinction of having been awarded more medals than any other photographer. His first big success was a montage composed of five exposures entitled "Fading Away" (plate 17). This sentimental composition shows a dying girl seated in an armchair, her mother and sister sitting and standing beside her in silent sorrow, and her father looking away out of the window. The frame bears a quotation from Shelley's "Queen Mab," which sets the mood for this portrayal of tragic death in the prime of youth. The English court was so taken by the picture that the Prince Consort not only bought it, he also gave Robinson a permanent commission for copies of any similar pictures he might make.

The technique Robinson used for these photomontages is revealed by some surviving sketches. On the basis of a precisely drawn sketch, he photographed the single subjects in exactly predetermined proportions, stuck the carefully cutout sections jointlessly together, and photographed the image thus obtained. The prints, elaborately framed in wood or passe-partout, were then sold as works of art.

Particular popularity was enjoyed by the picture of "The Lady of Shalott," an interpretation of Tennyson's poem of the same name, made in 1861 (plate 16). Much later, Robinson spoke of this picture, which was composed of five negatives, as follows: "I think I succeeded in giving the picture a very Pre-Raphaelite atmosphere, far removed from all naturalness, I mean entirely imaginary. But it was a grave mistake to try to deal with such a theme with our realistic art. With the exception of a 'dead Ophelia,' which I regard as a relapse, I never again occupied myself with themes that lie outside the limits of the life of our own time." Robinson was probably referring less to his staged country scenes composed of a number of negatives—for example, the "Country Party" taken in 1860 (plate 15)—than to his later, increasingly objective photographs, which were not based on the principle of montage. This departure from "art photography" coincided with extensive journalistic work by means of which Robinson became a widely read theoretician on photography.

The "art photography" with literary overtones practiced by Rejlander, Robinson, Julia Margaret Cameron, and others between 1850 and 1880 represented an extreme example of photography's dependence on painting. Even then, its artificiality aroused violent opposition among those who recognized photography as something new and different and independent of painting, and "art photography," which tried to compete with painting, was rejected as false and tasteless with especial vehemence by those who valued the precision and realism in photographic representations of people, architecture, landscapes, and objects.

The situation regarding the numerous attempts to create real photographic still-lifes that were independent of painting, and which tried to present something equally valid and valuable, was somewhat different. The still-life was recognized early as being an admirably suitable subject for photography since it was evident that the medium was cut out for the creation of objective, realistic likenesses of objects in their natural context and—by the conversion of the colored appearances into pure, subtly graduated tonal values—to reveal the true "life" of the objects, their formal expression, material quality, and texture. Apart from this, the still-life was obviously an ideal field of work for the early photographers since its static nature obviated the problems caused by long exposure.

The photographs by the French genre painter HENRI LE SECQ (1818–1882) may be regarded as representative of these still-lifes. Together with his friend Charles Nègre (1820–1879), he was the first success-

ful Calotypist in France, and soon after 1850, he began taking architectural photographs that are among the most technically flawless images ever made in the early days of photography. Le Secq's paper negatives, which were always in large format, were usually reprinted on positive paper by an industrialist from Lille named Louis Désiré Blanquart-Évrard (1802–1872), a passionate photographer who improved Talbot's Calotype process and introduced it into France, as well as developing a method of mass-producing excellent quality paper prints by a kind of conveyor-belt technique. The astonishing quality of Le Secq's architectural photographs is due at least in part to this pioneer of the photographic industry.

Although Le Secq regarded himself as an incorruptible servant of the nation as regards his pictures of historical architectural monuments, which he made in the capacity of official photographer to the Commission des Monuments Historiques, he allowed his painter's imagination a free rein when it came to his still-life photographs (plates 13 and 14). He did not, however, attempt to misuse the medium of photography to produce effects more appropriate to painting, as did so many of his contemporaries, but employed the specific qualities inherent in photography. Most of his still-lifes are simple and unpretentious in character, and Le Secq usually contented himself with bringing out the essential material qualities of his subjects and juxtaposing them with other textures. It is this conscious contrast between the different superficial appeals of well-harmonizing everyday objects which constitutes the special quality of Le Secq's still-lifes and even lends them the appearance of predecessors or anticipators of the "material studies" of the great photographers at the turn of the century.

It is a striking fact that throughout the history of photography up to and even beyond the turn of the century, painters were constantly enthralled by the new medium and even adopted it as their profession. A few of them—for example, Nadar (Gaspard Félix Tournachon, (1820–1910), a mediocre illustrator who became a great portrait photographer—were somewhat unoriginal painters and draftsmen on an undistinguished level who subsequently became great photographers by adapting their creative abilities to the laws of photography. Henri Le Secq was another case in point. Others, above all the ambitious "art photographers," merely transferred their artistic and intellectual ineptitude from one medium to another—from painting to photography—and it was not long before their attempts were recognized as worthless, although the same thing tends to occur in certain amateur circles even today.

The great artists of the nineteenth century, insofar as they were interested in photography at all—and a great many of them were, even if not as passionately as Edgar Degas—used the medium as a working aid and means of widening their visual horizons. Others isolated single elements of photographic technique and adapted them for their own purposes, and one of these usurpations of photographic methods was the technique of the *cliché-verre*.

This technique, which has its place at the intersection between graphic art and the photographic process, came about as follows: The negative process developed by Fox Talbot—a reversal process of light and dark—was a new discovery, the influence of which extended beyond photography into the thinking of the middle of the last century and even into philosophical speculations. On the other hand, the reversal concept had long been known to artists since it lies at the root of most graphic printing processes. Thus it was natural for painters interested in graphic mediums to turn to the negative-positive process and examine the possibilities it offered.

The fact that it is possible to produce a positive print—a reproduction with the dark-light relation reversed—by means of exposing a light-sensitive paper through a negative led to experiments in coating glass plates with an opaque adhesive layer. When parts of this compact layer were scratched off the glass plate with an etching needle, it became possible to use the plate as a "negative," and a photo-paper exposed through the etched plate produced an image in which the engraving appeared as a black line drawing. It was possible to make an unlimited number of prints from the engraved glass print; in other words, the cliché-verre was an image-bearing agent similar to the engraved woodblock or the etched copperplate from which any number of prints could be made. The difference between this and the so-called "original" graphic techniques is that in the latter the prints are produced by hand and in the former by a photochemical process; thus the cliché-verre process was sometimes referred to as the pigment print.

A few artists, familiar with the possibilities and limits of gravure printing techniques such as drypoint etching, were fascinated by the proportionment of light made possible by the control of the development of the paper prints; thus it was no mere chance that it was first and foremost the great masters of the Barbizon school, the pioneers of open-air painting, who worked with the cliché-verre process. Eugène Delacroix, the eldest member of this school and a member of the Société Française de Photographie, was passionately interested in photography and used it frequently as an aid in his painting. Regrettably, however, only a few of his cliché-verre etchings have been preserved.

The painter JEAN BAPTISTE CAMILLE COROT (1796–1875) used the cliché-verre technique most frequently in his later work, which consisted mainly of delicate, misty, atmospheric landscapes with subtly incorporated figures. His numerous prints made by

this method reveal the full extent and range of the photo-graphic process, from sketchlike jottings to full-scale pictorial compositions (plates 18 and 19). The same also applies to similar works by the landscape painters CHARLES FRANÇOIS DAUBIGNY (1817–1878) and THÉODORE ROUSSEAU (1812–1867) who, together with Corot, worked repeatedly with the cliché-verre process between 1854 and 1858. Whereas Daubigny tended to conjure up the atmospheric aspect of a landscape—for example, the play of moonlight upon water—by means of the cliché-verre technique (plates 20 and 21), Rousseau was more concerned with making minutely and precisely etched detailed landscape studies (plate 22). A contemporary and friend of these "landscapers," JEAN FRANÇOIS MILLET (1814–1875), also used the cliché-verre technique occasionally for his contemplative scenes of peasant life (plate 23), and it would appear that this technique was the favorite pastime of a small circle of artists with similar interests. Aside from some sporadic later attempts, the use of the cliché-verre method in graphic art and photo-graphics was, however, short-lived, perhaps due to the fact that genuine graphic-gravure techniques offered greater and more varied possibilities in the long run.

Pioneering attempts to exhaust and expand the possibilities of the new medium of photography led in quite another direction. From the very beginning, photographers were confronted with the problematic phenomenon of movement, and during their work with the still imperfect lenses and apertures of their clumsy cameras, and above all due to the long exposures necessitated by the relatively low sensitivity of the films and glass plates, they were forced to the conclusion that unblurred images of quickly moving objects, animals, and people were beyond their capabilities.

A shortening of exposure times gradually made it possible to capture the moving subject on the negative as a "still" image. This persuaded photographers that movement is made up of an infinitely large number of neutral, objective phases rapidly succeeding one another; but although a few photographers, irritated by the constant blurring of their images of moving subjects, carried out research into this phenomenon, hardly any of them tried to investigate movement systematically by photographic means. The real "conquest of motion" was left to two men who, for different reasons, employed photographic technique in motion studies: the Anglo-American photographer Eadweard Muybridge and the French physiologist Étienne Jules Marey, who was inspired by Muybridge to carry out his own research.

EADWEARD MUYBRIDGE (originally Edward James Muggeridge, 1830–1904) emigrated to the United States in 1852, without immediately distinguishing himself as a photographer. Gradually, however, he made his name, mainly due to his large-format pictures of Yosemite Valley and the world of industry. In 1869, he also developed the first practicable camera shutter which, together with the improved negative film, made it possible to make real instantaneous exposures. The possibility of capturing even the most fleeting single phases of movement with this apparatus led Muybridge to the idea of photographically documenting movement in series of images. His first attempts with a single camera proved unsatisfactory, and he subsequently set up first 12, and then an even larger number of identical cameras in front of a long wooden fence. He then fixed strings from points on the wall to the camera shutter releases, and with this device he finally succeeded in capturing the movements of a galloping horse in a systematic series of instant exposures for the first time in 1877. The result was astonishing. Immediately published in numerous American magazines, it showed that the true phases of movement were basically different from all previous conceptions, and particularly from the way they had previously been portrayed by painters.

Muybridge's experiments, which he greatly developed and improved during the years that followed, provided the impetus for a complete revolution in the concept of the nature of motion. One of the immediate results was that it became possible not only to capture systematic series of the phases of movement but also to reproduce the movements themselves. By means of an ingenious device in which the instant images mounted in rows could be made to move, it was possible to portray—and even to project—movements "fixed" by photographic means. Muybridge developed his apparatus on the basis of old "motion toys," and he gave it the name of "zoogyroscope" and later "zoopraxiscope." The device aroused great enthusiasm among both adults and children and provided the basis for many similar constructions. Above all, it ushered in the development of real "motion photography"—film technique—which is still based on the breaking down of continuous motion into a large number of "static" single pictures and projecting them at the same speed even today. An important first step in the field, although by no means the only one, was Edison's "kinetoscope," constructed in 1895.

In 1887, Muybridge's work was published in 11 volumes entitled *Animal Locomotion* and consisted of 781 Calotype plates, each bearing a full series of motion images. Apart from the representations of the movements of animals, the series devoted to the human figure, in which clothed and unclothed male and female models are shown in motion, are of especial interest (plate 24). It now became possible for the first time to study the way in which the human being rose from a chair, climbed a staircase, did a handstand, lunged against a fencing opponent, and performed many other actions. Interestingly

enough, it was the artists of the time who began by quarreling with Muybridge's often unfamiliar motion studies, although they later recognized them as valuable study material and used them accordingly.

ÉTIENNE JULES MAREY (1830–1904), who was chiefly interested in the movement mechanism of the human body in his capacity as a physiologist, was inspired by Muybridge's experiments to carry out his own research into the phenomenon of motion. He too regarded photography as the most suitable means of obtaining clear visible information, and his first step was the construction of a camera in the form of a "photographic rifle" for taking rapid successions of pictures of a bird in flight. Although he managed to obtain up to 12, and later up to 24, exposures per second, he was far from satisfied with his results. In 1882, he completed the construction of the "chronograph," a camera with a movable slit disc over a fixed photographic plate with which he greatly increased the number of exposures per second. In 1887, he added a movable plate to the construction, and shortly afterward he produced a roll-film camera. In fact, although Marey's technical developments had a determining influence on the evolution of cinematography, the results of his motion series exposures are even more important.

What Marey did was to dress his models in black, with white lines marked on their arms and legs and white dots on their joints. In a series of images taken of a continuous movement, the figure appeared as a motion structure against the black background; these images, apart from their graphic appeal, also provided valuable information for the scientist (plate 25). Although the methods have altered somewhat since the development of the stroboscope, similar visual material is still used in physiology today for the study of, for example, working processes.

Marey's work also included less complicated multiple exposures, which may be regarded as a kind of systemization of the chance multiple exposure of amateur photographers—extremely appealing, visually attractive multiple exposures of a subject superimposed in various phases of movement, which formed an important contribution to the theme of simultaneous portrayals of motion in the phototopographical image (plate 26). It was only 25 years later that these bold works by Marey, seen in a new light, were regarded as artistically justified: in the painting, graphic art, and photography of Italian futurism.

The further development of photography in the years that followed was not particularly favorable to creative experiments. From a phototechnical point of view, the last decades of the century were devoted to the consolidation and systematic development of that which had been achieved in the first onrush of activity, and the photo industry, which was rapidly developing both in Europe and the United States, forged ahead with the construction of cameras, the production of efficient negative and positive films and plates, and the manufacture of accessory equipment. As regards the artistic aspect, photography finally freed itself from its dependence on painting and established itself as a valid, autonomous branch of art. The turn of the century, with its quest for a new style of life and art, heralded the development of various kinds of photographic seeing and creation, which evolved into definite photographic styles. Most important of all was the emergence of a considerable number of outstanding photographic personalities whose way of seeing—published and publicized by numerous photographic journals and an increasing number of exhibitions—had a formative influence all over the world.

The liberal arts contributed little to photography's development around and shortly after the turn of the century. Painting retreated to areas that were largely closed to photography, for deformation of the realistic, representative, and spatial aspects of the picture in the interests of expressive impact, and a bold, even violent liberation of color—for example, in fauvism—were the essential characteristics of European expressionism that created a wide gap between painting and photography. In addition, the increasing tendency toward abstraction, the abandonment of sensibly perceptible visible reality, and the preoccupation with problems of pure form and color and the bare facts of space, volume, and surface, which were characteristic of the art of the first decade of the twentieth century, had little in common with photography which was, after all, bound to the world of visible appearances. Cubism, founded by Picasso and Braque, Vasili Kandinski's radical advance into the "nonrepresentational world," and the discovery of the elementary relationship between line, surface, space, and color in early Russian constructivism were all epoch-making changes in art that were far removed from the true interests of photographers. Attempts to create a new contact between art and photography, and above all to explode the rigid photographic traditions, were not long in following, however not, as might be expected, by the photographers, but by the progressive artists.

In 1908, the Italian poet Filippo Tommaso Marinetti published his *Futuristic Manifesto*, which was soon followed by similar proclamations. Unlike cubism, which had been accepted as formalistic in character, futurism purported to be a dynamic form of art immediately connected to contemporary life. City life with its noise, amusements, industry, and bright lights, technology in all its forms, and the speed of modern modes of transport—in short, the breathtaking rhythm of modern life—became the theme and prerequisite of all art. The dynamic representation of movement became the chief concern of the visual arts, and for this the futurists turned to one of photography's achievements—to the experi-

ments through which Muybridge and Marey had captured movement in visible form by means of the photographic image. Some futuristic paintings—for example, those of Boccioni, Balla, and Severini—have very much the appearance of multiple exposures of movement expressed through the medium of painting.

Strangely enough, only one man seems to have drawn any practical conclusions from this astonishing coincidence: ANTON GIULIO BRAGAGLIA (1890–1960). Although he was hardly known outside Italy, this brilliant personality was virtually the personification of the best aspects of "futuristic man." A writer, theoretician, theater and film director, stage designer, and photographer, Bragaglia was the founder of "fotodinamismo futurista," which he presented in a manifesto. In the fields of theater and film, Bragaglia visualized man contrasted against an artificial, geometrical, and dynamic background, which anticipated the kinetic flickering effects of the "Op Art" of the sixties (plates 27 and 28). His photodynamic experiments made between 1911 and 1916, in which he "dynamized" the human figure and suffused the static image with an effect of transitoriness by rapid, or dynamic, movement of the camera, were more significant in the development of photography (plates 29 to 32). These works, which had their parallels in Bragaglia's futuristic films, were isolated photographic experiments closely connected to the goals of a specific artistic movement, and although they were thoroughly in accordance with the futuristic aim of approaching life and reality as closely as possible by means of a dynamic technique, from the photographic point of view they represented a transition from the representation of reality to a kind of dynamic abstraction. The possibility of abstraction in photography was beginning to emerge.

After 1910, it began to look as if the gap between photography and modern art was no longer insurmountable, and the circle of distinguished photographers known as the "Photo-Secession" (founded in New York in 1902) played an important role in this context. Its initiator, the brilliant photographer and art exhibitor Alfred Stieglitz, devoted himself not only to the promotion of creative photography—to what became known as "pictorial photography"—but also to modern, progressive art. His "Gallery 291," which he termed a "laboratory and experimentary station," and in which works of the great photographers were confronted with works by European painters and sculptors, such as Picasso, Matisse, and Brancusi, provided Stieglitz with the opportunity for making fruitful new contacts, and directly or indirectly, these approaches and insights into the basic unity of all creative artistic activity had a great many consequences.

This is perhaps most clearly evident in the work of ALVIN LANGDON COBURN (1882–1965), a member of the "Photo-Secession." Optically sensitized by his inter-est in cubism, Coburn made experiments in, for example, taking photographs of a familiar city scene in such a way that "its perspectives become almost as fantastic as those of a cubistic work." Coburn asked: "Why shouldn't the camera-artist throw off the shackles of conventional representation and demand the freedom of expression which every art must have if it is to survive?" Distortion, exaggeration of light and shade, a preference for striking structures and textures, and strict geometrical concept principles led Coburn gradually to a genuinely abstract style of photography (plate 34). A tireless and ever-curious searcher in many fields, and more of an intellectual than a practician, he devoted all his energies to the liberation of photography from its dependence on visible reality. He was encouraged in his endeavors by his friend, the poet Ezra Pound, and it was through Pound that Coburn met the English artists of the vorticist group, an offshoot of French cubism, during a visit to England. Coburn developed a device consisting of three mirrors, which he used to make surprising photographs of transparent or opaque objects which he entirely dematerialized and formalized by multiple reflection (plates 35 and 36). Ezra Pound called these abstract photographs "vortographs," and they are among the earliest attempts at abstract photography.

It must have been photography's latent ability to create something more than mere likenesses of visible reality which suddenly drew the attention of artists to the medium. The striking change in the attitude of outsiders in favor of photography since 1916 had a number of reasons. First of all, all photographs, even the most realistic, are really abstractions by virtue of the alienation of "natural" color in a scale of gray tones between black and white, and this fact must have endeared photography particularly to artists who aspired to create abstractions of visible reality in their work. The departure from the familiar image led to a conscious antagonism toward outdated artistic traditions and toward conventional and academic art. But it was not only traditional content in artistic representations that fell out of favor but also the traditional techniques employed. In this aspect Picasso and Braque, who used sand, sawdust, and other "unworthy" and "foreign" materials in their pictures, and even included scraps of wallpaper, newspaper, or other wastepaper in their collages, had already paved the way. The search for new horizons in art was accompanied by a search for new materials and mediums, and the lighthearted or systematic employment of new materials resulted in works of art that were thoroughly in accordance with the new artistic aspirations. This all applied particularly to photography. Unlike painting or sculpture, the medium was unburdened by centuries-old traditions and conventions; it was capable of being regarded as a modern and, thanks to its wide diffusion, socially useful medium, and it was flexible

enough to be employed in the most unorthodox experiments.

It was first and foremost the representatives of Dada (founded in Zurich in 1916) who seized upon photography, for it fitted admirably into their passionate and even wrathful rejection of all traditional art and accepted technical methods, and they used it in the creation of a kind of "anti-art," which represented a protest not only against artistic tradition but also against a society that had been unmasked in the senselessness of the First World War. In the eyes of the Dadaists, there was only one therapy that could lead to their own redemption and the arousal of the world at large: the absolute rejection of all previous values, the renunciation of logic, the provocative cult of non-sense, and play with chance.

Jean Arp's assertion that he and his fellow artists created works of art "with all their might" in Zurich in the early days of Dada—not with paintbrushes and oil but by sawing, nailing, and gluing—bears witness to the passionate pleasure they took in their spontaneous use of materials with which they were able to produce new and unfamiliar effects. The photographic experiments that CHRISTIAN SCHAD (born 1894) carried out in Zurich during this period were definite fruits of this spiritual soil. This German painter and wood-engraver, who came from the areas of expressionism and cubism, was one of the co-founders of the Zurich Dada movement, which represented a specific attitude to life rather than a unified artistic style. The sources of inspiration of the Dada group included all kinds of *objets trouvés* and discarded objects that had lost their original significance and could be used as raw material which bore the enigmatic traces of an earlier life, and Schad was among those who collected such material.

In 1918, or possibly before, Schad hit upon the idea of laying his "finds" on unexposed photo-paper or glass negatives and fixing the compositions, "arranged by chance" (Jean Arp), on the photosensitive material by means of exposure. The poet Tristan Tzara, spokesman of the Zurich Dadaists, called these images, which recalled Fox Talbot's first photogenic experiments and lent the camera-less photogram a new significance, "Schadographs." But whereas Fox Talbot tried to produce exact, self-made likenesses of reality with this technique, Schad used the photogram for exactly the opposite effect: He produced abstract chance combinations from wastepaper, rags, and other waste materials (plates 37 to 40).

Schad once spoke of his invention as follows: "The attraction which I felt toward the things I found around me, on the street, in shop windows, in cafés, and even in dustbins made them appear useful and attractive in my eyes; for they radiated an enchantment and the patina of age. By combining the materials I found, I developed something new and created a new reality. My technique consisted of laying the objects on either photo-paper or a photo-plate and exposing them. It was possible to regulate the intensity of the light as desired—a procedure with which every photographer is familiar. It was also possible to expose two separate and different compositions on a single plate, or to combine them with one another. Superimposition was another possibility. There are a great many variations of combination—you only have to know how to choose and arrange correctly. All sorts of waste products can be useful if they are remodeled or supplemented. Everything depends on one's personal taste and ability."

For his photograms, Schad made extremely subtle use of the transparency or opaqueness of his materials, their structured or planar character, as well as elements of writing or fragments of photographic prints. Most of the signed images are negative—the fragments of reality appear reversed as it were in their shadow existence—a demonstration of the relativity of that which we call reality.

Schad was not the only Dadaist to experiment with photography. It is hard to establish if and to what extent his Schadographs, which appeared in Dadaist journals, inspired other Dadaists to make their own experiments with photography, but the fact remains that the photographic experiment achieved a virtually central importance, particularly among the Berlin Dadaists. Although mystification, false dates, and false interpretations were common among the Dadaists, it is nevertheless possible to say with a tolerable amount of certainty that it was the painter, sculptor, and poet RAOUL HAUSMANN (1886–1970) who was the first to advance into this field. In their active loathing of traditional art techniques, the Zurich Dadaists had already made the process of the "mounting" of all kinds of materials to form two- or three-dimensional images the focal point of their creative activities, and the "montage" became the professional ideal of the Dadaist movement. And it was not long before the "photomontage" found its place within this framework.

Raoul Hausmann described how he began making montages as follows: "In summer 1918, I began making pictures out of colored paper, newspaper cuttings, and posters. But it was during a holiday in a small fishing village called Heidebrink, on the island of Usedom in the Baltic, that I invented the actual photomontage. In nearly all the houses on the island, the families kept memorial certificates of the military service of the male members—colored lithographs showing the barracks, the town, and the portrait of a soldier (almost always a grenadier). The owner of the certificate was also represented by a photographic portrait. It was like a revelation: I suddenly realized that it was possible to create pictures solely out of cut-up photographs. Back in Berlin, I began working on the realization of this vision using photographs from the press and the cinema. In my enthusiasm, I needed a new name for the tech-

nique, and together with George Grosz, John Heartfield, Johannes Baader, and Hannah Höch, I decided on 'photomontage.' We chose this name because of our aversion to 'playing the artist,' for we regarded ourselves as engineers, preferred wearing working clothes, and maintained that we 'constructed' or 'assembled' our artistic creations."

Hausmann used existing photographic material, usually illustrations from magazines, to make collages in which the raw material was employed as an instrument for semiabstract representations of cultural or social criticism (plate 42); more frequently, however, he took the cutout motives right out of their original context and integrated them into new, grotesque, and sinister pictures. Through these images it became clear that a genuinely creative artist can succeed in combining fragments of reality into a new organic entity which endows the unreal with the persuasive power and palpability of reality (plate 41).

Hans Richter, himself a Dadaist and chronicler of the movement, said of photomontage: "The alienation of photography, which depicts visible reality, through the creation of new relationships of form and tonal values and the free use of realistic elements for the purpose of a political attack—this was the new Berlin dimension." And Hausmann remarked: "The Dadaists . . . were the first to use photographic material to create a new entity from structural fragments, often of a contrary character as regards their substance and their spatial nature, which extracted a new optical mirror-image from the chaos of war and revolution." In their sometimes malicious fantasy, Hausmann's photomontages are somewhere between those of his Berlin Dadaist friends John Heartfield and Hannah Höch.

HANNAH HÖCH (born 1889), the most sensitive, artistic, and subtle of the Berlin Dadaists, had a strong feeling for the grotesque, and she was able to express this through intelligent combinations of fragments from magazines. In most of her collages and photomontages, however, the visual, artistic aspect was in the foreground, and art was more important to her than politics in her work (plates 43 to 47). She was particularly successful when she used cutouts from color illustrations to include the element of color in her images, many of which are unsurpassed even today.

Many of her photocollages have a poetic character reminiscent of the dreamlike drawings and color images of, say, Paul Klee, or of the charm of the collages by the Hanover artist KURT SCHWITTERS (1887 –1948) who was unrivalled in his mastery of the art of making pictures with wastepaper and other waste materials. In Schwitters's work, the photographic element played an important although not determining role, particularly at the beginning of the twenties when he too joined in the enthusiasm for the *esprit dada* and was inspired to combine photographic and other paper fragments to form montages based on the mechanism of association (plate 33).

Unlike Raoul Hausmann, Hannah Höch, and Kurt Schwitters, JOHN HEARTFIELD (originally Helmut Herzfelde, 1891–1968) who, together with the draftsman George Grosz, was the leading figure in the political Berlin Dadaism and was called the "Dada-monteur" by his friends, regarded photomontage as a weapon —a weapon the convinced communist used against the bourgeois society and its offshoots, as well as against war profiteers, militarists, and exploiters of the workers and peasants (plates 57 to 60). Particularly following the late twenties, Heartfield used his technically refined and stylistically inimitable photomontages, now no longer dependent on the chance findings of suitable waste material but carefully and systematically planned, in the battle against the spread of National Socialism. Bertolt Brecht is quoted as saying that Heartfield "worked in a field created by himself, the photomontage, by means of which he practiced social criticism. Staunchly on the side of the working classes, he unmasked the warring powers of the Weimar Republic, and he fought Hitler from his exile. The works of this great satirist, many of which appeared in working-class journals, are considered by many—and this includes the present writer—as classics."

In addition to these biting commentaries on contemporary events, which may be regarded as parallels to Goya's critical etchings and Daumier's critical lithographs, other photomontages were produced during this period, which were less politically committed but more aesthetically ambitious. The work of the painter MAX ERNST (born 1891), who ran a kind of "Dada branch office" in Cologne with Johannes Baargeld and Jean Arp, falls into this category. From 1919 on, Ernst cut out single motives from commodity catalogues and combined them to form new, imaginative images— "marriages between otherwise incompatible realities." In 1920, he began using fragments from photographs in his collages, and he occasionally employed whole photographs, which he partially covered with fragments of other materials, producing the effect of glimpses into a piece of photographically perceived reality. The adhesive technique was sometimes also supplemented by drawn or painted elements. All this served Max Ernst in the creation of new entities of artistic compactness, magical energy, or dreamlike poetry from heterogeneous elements (plates 61 to 63). These collages, which were sometimes apprehensive and sometimes enigmatically cheerful in mood, formed a transition to surrealismus, of which this Rhinelander, who moved to Paris in 1922, was a cofounder.

Dadaism also provided the intellectual soil for the important photographic experiments of the American painter and photographer MAN RAY (born 1890). Together with Marcel Duchamp and Francis Picabia,

he worked on problems that were closely related to the activities of the Dadaists in Zurich, and which led to the foundation of a New York Dada movement. This was during World War I, when Ray still lived in New York. In 1921, he moved to Paris, where he experimented in a number of fields and worked as a fashion photographer for Paul Poiret.

During this work, he stumbled by chance—the great helper of the Dadaists—upon a method of creating a new kind of image. In the darkroom, where he was making contact prints from his large-format negatives, he "stumbled on a process for the production of photographs without the use of camera. Without my having noticed it, an unexposed photo-paper had slipped beneath other exposed papers. I noticed my mistake as I placed it in the developing tray and no picture appeared. Entirely mechanically, I placed a small glass container, a measuring cylinder, and a thermometer on the wet paper in the tray and turned on the light. The result was not simply a silhouette of the objects, for they appeared distorted and bore the reflection of the glass at varying distances from the paper. The section of the paper that had been directly exposed to light stood out from the dark background like a relief. I laid aside the important work on which I was engaged and immediately made a few similar prints. I later called these photograms "Rayograms" (plates 48 to 56).

Tristan Tzara saw these images shortly afterward and declared them to be superior to those by Schad which he had seen in Zurich. In 1922, the first album of Rayographs appeared in Paris with a foreword by Tristan Tzara and entitled *Les Champs Délicieux*. Man Ray gave these photograms in traditional style (Daguerreotypes, Talbotypes, Schadographs, and the like) a name which contained his own name as inventor, but his contemporaries were aware of the double meaning of the word, which implied that light rays were necessary for the creation of Rayographs.

Man Ray continued his experiments for many years, together with his portrait photography and photomontages with which he took an active part in the manifestations of the Paris surrealist group. His impressive and very personal portraits of the prominent personalities of the twenties and thirties earned Ray the reputation as one of the greatest photographers of this turbulent era, and his photograms, which quickly became known through publication in magazines, not only exploited the possibilities of this new technique to the full but also gave a determining impetus to the increasing interest in abstract photography. In addition, his photomontages—which were frequently compositions of different aspects of the same subject—and a number of somewhat playful photographic interpretations of reality (plate 49) placed him in the ranks of the greatest initiators of experimental photography.

"For whether a painter, emphasizing the importance of the idea he wishes to convey, introduces bits of ready-made chromes alongside his handiwork, or whether another, working directly with light and chemistry, so deforms the subject as almost to hide the identity of the original and creates a new form, the ensuing violation of the medium employed is the most perfect assurance of the author's convictions. A certain amount of contempt for the material employed to express an idea is indispensable to the purest realization of this idea." In these words, Man Ray formulated his credo as a photo-experimenter; and in answer to the question as to what provided his inspiration for creation in so many fields, Ray replied: "Cheerfulness and freedom are the leading motives in my work."

Man Ray had an opponent who achieved similar results in the same years, but worked far more systematically and thought much more deeply about the medium of photography than the lighthearted Dadaist and surrealist Man Ray—the Hungarian constructivist painter LÁSZLÒ MOHOLY-NAGY (1895-1956). Quite apart from all phototechnical and photoaesthetic theories, Moholy was the first to think seriously about photography as an expression of our technological age and to formulate its place within the various artistic mediums, first and foremost in the Bauhaus book *Malerei, Fotografie, Film*, published in 1925.

It has been frequently discussed, often with erroneous arguments, as to who invented the modern photogram. In truth, different artists in approximately the same years, but in different places and for different reasons, came upon the medium. In order to radically improve the efforts of photography to establish itself as an art, experiments in photography occupied many minds around 1920. The fact that the Dadaist experiments with photographic materials undertaken by the Russian Constructivists were inspirational in this context is not to be taken lightly. After the October Revolution, certain progressive Russians utilized montages containing photographic elements in such political compositions as advertisements and posters. The first photomontages resulting from this art form were created for Rosta, the Russian telegraph service. Of the progressive group, Wladimir Tatlin, El Lissitzky, and Alexander Rodtschenko made the most extensive use of cut-up photographic reproductions in their work. The greatest number of and most important Russian photocollages were created by Rodtschenko. Meanwhile, Lissitzky, during his stay in Germany between 1923 and 1928, actually employed photomontages for modern typography in sample books which he published combining photographic and typographic elements. Without anyone's knowing it, other people may have borrowed from these processes during this time. What effect the photogram had is reported by Lucia Moholy, a con-

temporary witness and active participant in these experiments: "Every single one of them found or discovered cameraless photography independently and in different ways."

Moholy's preoccupation with the idea of the photogram is described by his wife in this manner: "I distinctly remember the circumstances of its origin. In the summer of 1922, during a stroll along the Rhön, we resolved the problem of production and reproduction independently of the ideas of Schad, Man Ray, and Lissitzky. This point marked the beginnings of our own efforts in developing the photogram technique" (plates 64 to 72). Moholy had already presented these ideas in 1922 in the Dutch publication *De Stijl*. After he had become master of the Bauhaus in Weimar in 1923, a comparable entry was discovered in his book *Malerei, Fotografie, Film*.

In her publication *Marginalien zu Moholy-Nagy*, Lucia Moholy wrote: "For our photogram experiments, we used printing-out paper or daylight paper, which made it possible to observe the picture in all phases of development . . . During the day, we each went our separate way; in the evening, the photographic experiments were continued with increased enthusiasm in a make-shift darkroom." It was not until 1926, after the Bauhaus had moved to Dessau, that Moholy-Nagy and his wife had a proper laboratory at their disposal, where they worked on the photogram with new and improved techniques. "We could now use artificial light, but we were still tied to the paper base. Neither in Dessau nor later in our flat in Berlin did we dare to use highly sensitive negative material for our experiments with the photogram." Thus the photograms made on paper of a maximum of 7" × 9½" were unique examples, and it was not possible to make contact copies of them. Later, however, it became possible to reproduce them by photographic means.

The large number of photograms and similar photographic experiments Moholy-Nagy made in the twenties reveal that in spite of his almost childlike joy in his experiments, he was committed to a definite formal endeavor, which gives his "light graphics" the appearance of deliberately controlled compositions. On the other hand, Moholy was first and foremost interested in problems relating to creating with the medium of light, and the combination of these two interests culminated in the "Light Requisite," a three-dimensional spatial construction, in 1929. In their capacity of abstract light studies, many of the photograms in a sense anticipated this light-kinetic object.

Perhaps in order to distinguish his works from the more usual photomontages, Moholy-Nagy called them "photoplastics." Most of them were strongly constructivist in character and usually consisted of linear or planar connections between positive or negative photographic figure images. Contrary to the widespread opinion that Moholy-Nagy introduced photography to the Bauhaus, there was, in fact, no photographic department there during his professorship either in Weimar or Dessau, and it was only after his departure that Walter Peterhans opened a workshop for photography in 1929.

From the very beginning, however, the Bauhaus had been intensively occupied with the phenomenon and material of photography. In 1919, Johannes Itten taught his pupils how to handle it systematically as a creative medium in his "preparatory course." For the study of textures and materials, Itten also encouraged the use of black-and-white and colored photographic illustrations from magazines, and one of the fruits of this instruction was the series of visions of the "metropolis," or even the "megalopolis," which Itten's pupil PAUL CITROËN (born 1896) created between 1922 and 1924 as his interpretation of the set theme of "The City"—an almost jointless, extremely skillfully composed collage of cutouts from magazines, in which the big city, with its skyscrapers, blatant advertisements, and tangle of arterial roads and urban railway systems is depicted as a fascinating but alarming vision (plate 83).

Photographic experiments were carried out mainly in the Bauhaus workshop for typography, advertising, and exhibition design, which was directed by Herbert Bayer between 1925 and 1928. Photography was used as a counterpart to textual information in its capacity of visual information and eye-catcher, always in the sense of constructive two-dimensional design which, combined with the typographical material, formed an optical unity. The painter and graphic artist HERBERT BAYER (born 1900) took a keen interest in photographic experiments following his years at the Bauhaus in Berlin up till his emigration in 1938, and he continued to incorporate photographic elements in his collages under the influence of international surrealism.

At the beginning of the thirties, in connection with a project for a picture story entitled "Man and Dream," Bayer created a large series of photomontages. He described his technique as follows: "Photographs are cut out, their parts are put together in a new form and occasionally retouched. Then the finished montage is rephotographed." Eleven of these photomontages were published as a portfolio in 1936, among them the typical and surreal "Self-portrait" (1932) made with a show-window dummy (plate 73), which is regarded as a masterpiece of surrealist photomontage; the considerably more profound "Lonely City Dweller," which conjures up the imaginary world of the Belgian surrealist René Magritte in a disquieting fashion (plate 74), also dates from 1932. Compared to these well-founded surrealist photomontages, the work of (among others) the Belgian painter and poet EDOUARD L. T. MESENS (1903–1971) has a somewhat superficial and

arbitrary effect. Nevertheless, Mesens's pictures, such as "Portrait of a Poet" (approximately 1926), reveal that he was thoroughly capable of using a subtle combination of the photogram, photomontage, and collage to produce images that fully complied with the basic demands of surrealism—the combination of several fragments of reality to form a new, poetic, and dreamlike pictorial reality (plate 75). The fact that the fantastic photomontage was widely employed as an instrument of artistic, political, satirical, and sometimes merely humorous communication is evident from the fact that it was published not only in cultural journals, such as the *Querschnitt*, but also in general-interest illustrated magazines. An example of this is the grotesque montage entitled "The New Paradise" by the Berlin photographer SIEGFRIED FRANK, which appeared in the *Welt-Spiegel* in 1928 (plate 76).

Unlike the numerous painters and other artists who felt drawn to the medium of photography in the twenties and thirties and used it for their various experiments, FRANCIS BRUGUIÈRE (1880–1945) was a professional photographer. Although this American artist came originally from the field of painting, he was a member of the "Photo-Secession" and soon turned his attention exclusively to photography. A sought-after theater photographer, he became increasingly fascinated by the phenomenon of light and began to concentrate solely on light studies. In his capacity as a theater producer, he first of all attempted to use light as an all-important element in the New York Theater. From 1925 onward, he concentrated exclusively on photography and produced strongly expressive and pictorial photographs for which he used a wide variety of techniques, including multiple exposure, photogram, montage, hard and soft contrast, and the like (plates 77 to 82). These "light abstractions" and "photo drawings" were exhibited for the first time in Herwarth Walden's "Sturm" Gallery in Berlin in 1927, and they made a considerable contribution to the acceptance of the artistic photographic experiment in art exhibitions. In the Paris World Exhibition of 1937, Bruguière created monumental photographic wall pictures for the English pavilion, thereby proving beyond dispute that photography can hold its own with painting in this field as well.

An overall view of the photographic experiments of the twenties and early thirties would appear to show that a peak in the employment of the different and sometimes contradictory uses of photography was reached around 1928. Two important events in the history of photography took place during this period. First there was the exhibition "Photo and Film," held in Stuttgart in 1929, which provided a magnificent international panorama of all progressive achievements and the whole range of photography, from the then new "objective photography" founded by the Swiss photographer Hans Finsler to the abstract experiments by the constructivists. In his fundamental work of the history of photography, Peter Pollack refers to this "tradition-shattering international exhibition."

The other event was the picture volume entitled *Foto-Auge* (Photo Eye), which also appeared in Stuttgart in 1929, in which the art critic Franz Roh and the typographer Jan Tschichold presented a concentrated and highly interesting account of the important achievements of the century. The introduction by Franz Roh emphatically underlined the fact that the real impetus and regeneration came from "unprejudiced outsiders," and he drew special attention to the creative experiments, and in particular the photogram and photomontage. "The montage is based on a deep need of human imagination . . . In reality-grafts of this kind, we see the emergence of an entirely new, rich creative humor." Nor did Roh hesitate to speak of a new dimension by means of which all creative problems might be solved.

The high expectations of these years, so full of enthusiasm for experimentation and belief in the future, were not to be fulfilled, however. The courage of the discoverers was checked by the international economic crisis and, at least in Germany, the free development of creative artistic activity was drastically curbed following 1933. The gloomy threat of war, which was in the air long before 1939, crippled artists all over the world. All those who could, tried to save their own skins at the last minute, and in addition to actual emigration, an "inner emigration"—the retreat to an introverted creativity, which was often crippled by the bare necessity of survival—became prevalent.

The artistic avant-garde came together once again, albeit slowly and laboriously, during and after World War II, in a basically changed world with new conditions and new demands. In the history of photography, like in other fields, a new era—in the words of Karl Pawek an "optimal era"—began. New masterpieces of photography were created, new experiments carried out—some of them based on previous experience—and new connections between art and photography were established. It is even true to say that photography penetrated the domain of art in a hitherto unprecedented fashion, and it became that which it remains today: a genuine vehicle of artistic communication. This, however, is another chapter in the story of the photographic experiment as an art.

Biographical Notes

HIPPOLYTE BAYARD (1801–1887)

Pioneer of French photography, little recognized even today. His independent process for the fixing of "light drawings" (dessins photogéniques) consisted of the direct production of positive paper prints using silver chloride. On June 24, 1839, Bayard displayed his images at an exhibition in Paris. This was the first photography exhibition in the world, and it took place nearly two months before the famous publication of Daguerre's process by Arago. The several hundred photographs by Bayard that have been preserved (the later images made with the Talbot process) include still-lifes, genre themes, portraits, and architectural views.

Bibliog.: Lo Duca: *Bayard, der erste Lichtbildkünstler*, Paris 1943.

HERBERT BAYER (1900)

Painter, typographer, exhibition designer. Between 1921 and 1923, studied at the Bauhaus in Weimar; 1925–1928, director of the advertising workshop at the Bauhaus in Dessau. Later active in Berlin as advertising designer and photographer. Turned to surrealism around 1930. In 1932, used the photomontage for free surrealist images in the picture-story "Mensch und Traum" (Man and Dream), part of which was published in 1936. Has lived in the U.S.A. since 1938; played an important part in the development of the Cultural Center in Aspen, Colorado.

Bibliog.: Herbert Bayer: *Visuelle Kommunikation, Architektur, Malerei*, Ravensburg 1967.

ANTON GIULIO BRAGAGLIA (1890–1960)

Many-sided representative of Italian futurism, active as writer, critic, theater producer, stage designer, photographer, and film director (Perfido Incanto, 1916). In photographic and cinematographic experiments, he tried to fulfill the futuristic demand for the inclusion of the dynamics of movement in the image by moving the camera during exposure. He founded "Photodynamism" with a manifesto on futuristic photography.

Bibliog.: A. G. Bragaglia: *Fotodinamismo futurista*, Rome 1913.

FRANCIS BRUGUIÈRE (1880–1945)

American painter who turned to photography at an early date and soon became a leading member of the "Photo-Secession" in New York. In addition to his practical activities as a much sought-after theater photographer, Bruguière experimented with double exposures and montages. Later on, he was chiefly interested in the phenomena of light. From 1925, abstract photographic experiments with light on a futuro-cubistic basis, usually using the photogram, the montage, and the like. His "light abstractions" have been widely exhibited since 1927 and gave rise to much discussion about the relationship of photography to art.

JULIA MARGARET CAMERON (1815–1879)

Lady of the English high society, with outstanding literary and artistic talents, who turned to photography for her own pleasure and quickly became one of the greatest photographers of her time. Her portraits of personalities of Victorian English society take their place among the masterpieces of portrait photography. One of the secrets of her art was the use of large-format glass negatives. She also tried to portray literary themes and allegories through photography in Pre-Raphaelite style. Her photographic activities ceased when she moved to Ceylon in 1875.

Bibliog.: Helmut Gernsheim: *Julia Margaret Cameron, Pioneer of Photography*, London 1948.

PAUL CITROËN (1896)

Berlin painter. From 1922–1925, studied at the Bauhaus in Weimar. Inspired by his teacher Johannes Itten, he turned his attention to the photocollage which, under the influence of the Berlin Dada movement of which he was a member, sometimes included grotesque elements. Active since 1927 in Amsterdam and The Hague. Lives as a free-lance painter in Wassenaar.

ALVIN LANGDON COBURN (1882–1965)

Member of the New York "Photo-Secession." After beginning as a portrait photographer, Coburn turned to Eastern art and comparative religion. Settled in England around 1930 and returned to photography. Influenced by his friend Ezra Pound, he sought ways of liberating photography from its dependence on reality. In close collaboration with the abstract painters of the "vorticism" school, an English form of cubism that stressed rhythmic movement, he developed a threefold mirror system which enabled him to create abstract geometrical photographic compositions. The poet Ezra Pound invented the word "vortographs" for these images.

JEAN BAPTISTE CAMILLE COROT (1796–1875)

French painter and etcher. Founder of the post-classical, intimate-mood landscape painting (Barbizon school). For a time, Corot used a collodion-coated glass plate instead of a copperplate for his etchings. From the engraved and developed photographic plate, he was able to produce an unlimited number of paper prints using photographic technique. Through the correct relationship between exposure and development, he achieved subtle graphic effects by the use of this *cliché-verre* technique.

CHARLES FRANÇOIS DAUBIGNY (1817–1878)

French landscape painter and member of the Barbizon school. Like his friends Corot and Rousseau, he used the *cliché-verre* technique as a flexible graphic medium for some years.

MAX ERNST (1891)

Surrealist painter from Brühl near Cologne. In 1919, together with Johannes Baargeld and Jean Arp, he founded a Cologne branch of Dadaism and worked intensively with various collage techniques. His real invention was the mounting of elements from old woodcut illustrations to form imaginative collages. At the beginning of the twenties, Ernst turned once again to the photocollage, employing other collage elements as well as drawn-in components. Moved to Paris in 1922; active member of the Paris surrealist group led by André Breton since 1924. Today, a veteran of surrealist art living in Huimes near Chinon.

Bibliog.: John Russell: *Max Ernst, Leben und Werk*, Cologne 1966.

SIEGFRIED FRANK (?)

Berlin photographer, active in the late twenties. The montage shown here, composed of distorted photographs, appeared in *Welt-Spiegel*, a Berlin illustrated magazine, and is proof of visual contemporary criticism influenced by Dadaism and futurism in the daily press.

RAOUL HAUSMANN (1886–1970)

Viennese painter who, after turning to futurism in Berlin in 1918, was a founder of the "Club Dada" and became one of the spokesmen of Dadaism. He is regarded as the real inventor of the modern photomontage as well as of the "Lautgedicht" (phonetic poem). Whereas his friends George Grosz and John Heartfield devoted themselves to committed political and sociological criti-

cism, Hausmann—often in collaboration with Kurt Schwitters—defended the position of Dada in the capacity of a "Dadasoph." In 1933, emigration; from 1938, in France where he lived and worked in Limoges as a painter, journalist, and poet who was, however, only "rediscovered" shortly before his death.

Bibliog.: Raoul Hausmann: *Am Anfang war Dada*, Steinbach-Giessen 1972.

JOHN HEARTFIELD (1891–1968)

Original name: Helmut Herzfelde. Together with his brother Wieland (founder of Malik Publishers) and Raoul Hausmann, Richard Huelsenbeck, George Grosz, and others, he was a leading personality of Berlin Dadaism. In 1920, co-organizer of the "First International Dada Fair" in Berlin. Heartfield used the technique of the photomontage as an instrument in his political battle against capitalism and militarism in favor of the working classes. He published his satirical photomontages, which were also concerned with the fight against nationalism, in numerous magazines, and in later years above all in the *Arbeiter-Illustrierte-Zeitung*. The carefully constructed photomontages, in which the element of chance was completely excluded, were used by Heartfield not only as instruments of political satire but also for book covers for Malik Publishers.

Bibliog.: Wieland Herzfelde: *John Heartfield, Leben und Werk*, Dresden 1969.

DAVID OCTAVIUS HILL (1802–1870)
ROBERT ADAMSON (1821–1848)

The Scotsman Hill began as a book illustrator and landscape painter. A commission to paint a group portrait of the 474 founders of the Free Church of Scotland led him to turn to photography as a working aid in 1843. He found an ideal assistant in the young photographer Adamson, and right up till Adamson's early death, the two artists worked together to produce over 1500 Calotypes, mainly consisting of portraits and figure studies. Many of these photographs are extremely fine and include studies of personalities of the Scottish society as well as anonymous images of the working classes. Hill's pictures of fishermen are among the first photographic representations of the daily life of the working man. He gave up photography after Adamson's death.

Bibliog.: Heinrich Schwarz: *D. O. Hill, der Meister der Photographie*, Leipzig 1931. Heinrich Nickel: *D. O. Hill*, Halle 1960.

HANNAH HÖCH (1889)

Berlin painter, occupied with papercollage since about 1916, and under the influence of Raoul Hausmann, with photomontage since 1918. In 1919, co-founder of the Berlin Dada group. Used both fragments from original photographs and photographic reproductions for her imaginative compositions. Her prolific, partly Dadaistic and grotesque and partly surrealist and poetic collages greatly contributed to the acceptance of the photomontage as a serious branch of art.

Bibliog.: Hannah Höch: *Fotomontagen und Gemälde*, Kunsthalle Bielefeld 1973.

HENRI LE SECQ (1818–1882)

Genre painter and etcher who turned to photography around 1850 and became one of the first "Talbotists" in France. His main photographic work consists of his invaluable pictures of French architectural monuments. His still-lifes are, however, more interesting from an artistic point of view, since he rescued this area of photography from its slavish dependence on painting.

ÉTIENNE JULES MAREY (1830–1904)

French physiologist who developed an interest in observing the movements of men and animals. Inspired by Muybridge's motion images, which failed to satisfy him from a scientific point of view, he tried to develop a technique of his own for action photographs. For this purpose he constructed a "photographic gun" and other apparatus for the photographic "arrest" of movement, such as the photochronograph with slit disc and at first fixed, and later movable, negative plate. Like Muybridge, Marey was one of the pioneers of cinematography.

Bibliog.: E. N. Bonton: *Hommage à Étienne Jules Marey*, Paris 1963.

EDOUARD L. T. MESENS (1903–1971)

Belgian poet and journalist. Closely connected with the Paris surrealist group since the mid-twenties and spokesman for surrealism in Belgium, together with the painter René Magritte. Among Mesens's artistic work were collages, photomontages, and drawings, often poetical and humorous in character.

JEAN FRANÇOIS MILLET (1814–1875)

French painter of the realist school, whose main theme was the peasant's life determined by religious rules. A follower of the Barbizon school, his attention was drawn to the *cliché-verre* technique by the work of Corot and Rousseau, and he employed it for the production of etched figure studies of peasants.

LÁSZLÒ MOHOLY-NAGY (1895–1946)

Hungarian constructivist painter who was appointed to the Bauhaus in Weimar in 1923, and later to Dessau where he directed the preparatory course and the metal workshop until 1928. Carried out systematic light and color investigations in the fields of painting, photography, and cinematography; in addition, he worked with typography, and after 1928, stage design in Berlin. He was particularly interested in specifically artistic photograms, which he created together with Lucia Moholy after 1922. Later, apart from other photographic experiments, he created constructive photomontages closely connected to his paintings, which have been labeled "photoplastics." In 1935, emigrated to London; in 1937, moved to the United States. Co-founder and director of the "New Bauhaus," later the "Institute of Design" in Chicago.

Bibliog.: Lászlò Moholy-Nagy: *Malerei, Fotografie, Film*, Munich 1925 (new edition: Mainz-Berlin 1967). Franz Roh: *60 Fotos von L. Moholy-Nagy*, Berlin 1930.

EADWEARD MUYBRIDGE (1830–1904)

Originally Edward James Muggeridge. Emigrated to the United States from England in 1852. Official photographer to the government, later to steamer and railway companies, in which capacity he contributed to the "photographic discovery" of America. Since 1872, experiments in "arresting" movement—for example, of galloping horses—in systematic photographic series of 12, and later 24, images. With constantly improving techniques, Muybridge worked on widely differing human and animal movements. In 1887, he published this material under the title of *Animal Locomotion* in 11 volumes, with a total of 781 movement sequences. The "zoopraxiscope," introduced in 1881, is an important predecessor in the evolution of cinematography.

Bibliog.: Kevin MacDonnell: *Der Mann, der die Bilder laufen liess*, Bibliothek der Photographie, Vol. 4, Lucerne and Frankfurt.

MAN RAY (1890)

Painter and photographer from Philadelphia, since 1912 in New York, and from then on alternately in New York or Paris. Together with Marcel Duchamp and Francis Picabia, founder of the American parallel movement to Dadaism after 1915. In 1922, first ab-

stract photograms, which he called "Rayographs" or "Rayograms," published in 1922 in Paris in an album entitled *Les Champs Délicieux* by Tristan Tzara. Man Ray was later active as a fashion, society, and art photographer, as well as a surrealist painter.

Bibliog.: Man Ray: *60 Years of Liberties*, Milan 1971. Man Ray: *Photographs 1920–1934*, Paris-New York 1934.

OSCAR GUSTAVE REJLANDER (1813–1875)

Swedish painter who moved to England in 1852. Soon started using photography as a working aid for his painting of portraits. Subsequently began trying to transfer the allegorical style of painting into the medium of photography. Used numerous negatives for his portrayals, usually including a number of figures, of sentimental themes that corresponded to the taste of his time. His main work, "The Two Ways of Life," a montage made from over 30 negatives, created a sensation at the Art Exhibition in Manchester in 1857. His physiognomic studies created for Charles Darwin's "The Expression of the Emotions in Man and Animals" in 1872 were more valuable than his artistic compositions.

HENRY PEACH ROBINSON (1830–1901)

English painter who turned to photography in 1854. Like Rejlander, he attempted to create compositions, most of them illustrating themes from English poetry in Pre-Raphaelite style, by the use of a number of specially made negatives. Robinson was the most successful English photographer of his time and exercised a considerable influence on the development of photography by the publication of books, among them *Picture Making by Photography*.

THÉODORE ROUSSEAU (1812–1867)

French landscape painter and etcher, main representative of the Barbizon school. Like his friends Corot, Daubigny, and Millet, he was interested in the graphic possibilities of the *cliché-verre* technique.

CHRISTIAN SCHAD (1894)

German expressionist painter, co-founder of the Dada movement in Zurich in 1916. In connection with Dada experiments with new mediums and techniques, he worked with light-sensitized papers from 1918 onward, thus achieving abstract and usually fantastic "light graphics" without the use of the camera, which are reminiscent of Fox Talbot's photogenic drawings and which Tristan Tzara called "Schadographs." His compositions, some of which were published in Dadaist journals and in which the objects photographed appear in negative form, were the predecessors of the modern photogram.

Bibliog.: Christian Schad: *Dada-Schad-Dada*, Milan 1970.

KURT SCHWITTERS (1887–1948)

Painter, sculptor, poet, and journalist who, inspired by Dadaism, developed his own "Merz-Art" in Hanover in 1918. His work included collages and relief images made of wastepaper and other materials. Schwitters occasionally used elements of photographic illustrations and original photographs, which he often alienated in the framework of his composition.

Bibliog.: Werner Schmalenbach: *Kurt Schwitters*, Cologne 1967.

WILLIAM HENRY FOX TALBOT (1800–1877)

English university scholar and inventor; was occupied with studies in mathematics, chemistry, botany, geography, languages, and photography. After working with the camera lucida and the camera obscura, he sensitized ordinary writing paper to light by treating it with silver nitrate at his country seat, Lacock Abbey, in 1835. By laying plants, lace, and its like on the paper and exposing them to sunlight, he achieved "nature images," or "photogenic drawings." Later, he succeeded in fixing the negative paper print with fixing salts developed by Sir John Frederick William Herschel (1791–1871) and subsequently rephotographing the negative image, thus achieving a positive picture. He thus founded the basis of the negative-positive process. He called his images "Talbotypes," or "Calotypes" *(kalos* = beautiful), to distinguish them from Daguerre's "Daguerreotypes," and he patented his process on February 8, 1841, six months before Daguerre. Talbot was not only the founder of Calotypy—negative and positive paper prints capable of being developed and fixed (and thus the unlimited reproductability of the photographic image)—but also the initiator of the photogram by virtue of his photogenic drawings made without the use of the camera. His photographic studies were published in *The Pencil of Nature* between 1844 and 1846, the first photographically illustrated book. Apart from his photograms, Talbot produced a large quantity of photographs, including portraits of his contemporaries and unposed images of everyday life.

Bibliog.: André Jammes: *William Fox Talbot, Inventor of the Negative-Positive Process*, Photography: Men and Movements, Vol. 2, Lucerne and Frankfurt 1972.

ABOUT THE AUTHOR

WILLY ROTZLER was born in Basel in 1917 and studied art history, archaeology, and German language and literature. After some years as an expert reader in a firm of art publishers, he was occupied as curator of the Museum of Arts and Crafts in Zurich between 1948 and 1961, during which period he organized numerous thematic and monographic exhibitions on photography. From 1962 to 1968, he was editor of the cultural monthly magazine *DU* in Zurich, in which he published regular contributions on the history of photography and contemporary photographers. For many years a lecturer in twentieth-century art at the University of Zurich, he now works as a free-lance writer on art in his home in Hausen am Albis near Zurich. He is a member of the Swiss Art Commission and the Commission for the City of Zurich, and he has been president of the Swiss section of the Association Internationale des Critiques d'Art for many years.

Numerous publications in the form of books, magazines, newspapers and exhibition catalogues, mainly on contemporary art, photographic subjects, and environmental planning, are of superior value. His most important recent books are: *Alberto Giacometti*, Berne 1970; *The Swiss Avantgarde*, New York 1971; *Objekt-Kunst, von Duchamp bis Kienholz*, Cologne 1972; *Johannes Itten, Werke und Schriften*, Zurich 1972; and *Gesichter Afrikas* (with Ernst Winizki), Lucerne 1972.

ROMEO E. MARTINEZ

As editor of this series, Romeo E. Martinez crowns an almost 40-year career as journalist and picture director.

Martinez was chief of the illustration departments with the magazines *Vu* and *Excelsior* in Paris and is a member of the *Conseil en illustrations de la "Grande Encyclopédie française."* His ten years as editor-in-chief of the monthly magazine *Camera* in Lucerne contributed greatly to the international success of this journal. He has been responsible for the organization of the biennial of photography in Venice.

Captions

WILLIAM HENRY FOX TALBOT

1 Photogenic drawing (1839).
2 "Boats in Harbor, Low Tide." Calotype (approximately 1845).
3 "Harp Player"; Miss Horatia Fielding, Talbot's half-sister. Calotype (approximately 1842).

HIPPOLYTE BAYARD

4 Photogenic drawing. Photogram with etching, feathers, and material (approximately 1839).
5 "Attic." Calotype (approximately 1846 to 1848).

DAVID OCTAVIUS HILL and ROBERT ADAMSON

6 "D. O. Hill and Professor James Miller." Calotype (approximately 1843 to 1848).
7 "Greyfriars Cemetery." Calotype (approximately 1843 to 1848).
8 "Mrs. Anne Rigby and her daughter Elizabeth." Calotype (approximately 1843 to 1848).

OSCAR GUSTAVE REJLANDER

9 "Hard Times." A so-called "ghost photograph." Composition of several negatives (1860).
10 "The Two Ways of Life." Composition of over 30 negatives (1857).

JULIA MARGARET CAMERON

11 "King Lear." Albumin print (1872).
12 "Sister Spirits." Albumin print (1865).

HENRI LE SECQ

13 "Still-life with Peach." Calotype (approximately 1856).
14 "Still-life with Fishes." Calotype (approximately 1855 to 1856).

HENRY PEACH ROBINSON

15 "Women and Children at a Country Party." Albumin print of staged photographs (1860).
16 "The Lady of Shalott." Albumin print of staged photographs (1861).
17 "Fading Away." Albumin print of five staged negatives (1858).

JEAN BAPTISTE CAMILLE COROT

18 "Death and the Maiden." Cliché-verre (approximately 1854 to 1858).
19 Sketches, Cliché-verre (approximately 1854 to 1858).

CHARLES FRANÇOIS DAUBIGNY

20 "Le Bosquet d'Aisnes." Cliché-verre (approximately 1854 to 1858).
21 "Effet de Nuit." Cliché-verre (approximately 1854 to 1858).

THÉODORE ROUSSEAU

22 "Le Cerisier de la Plante à Bian." Cliché-verre (approximately 1855).

JEAN FRANÇOIS MILLET

23 "Femme Vidant Son Seau." Cliché-verre (approximately 1854 to 1858).

EADWEARD MUYBRIDGE

24 (Above) "Woman Running and Jumping." Collotype (1885). (Below) "Fencing." Collotype (1885).

ÉTIENNE JULES MAREY

25 (Above left) In this chronophotographic study, the subject is dressed entirely in black with white lines and dots on his arms, legs, and head so that the movements become visible. (Above right) The result: A serial picture made up of individual movements takes the place of the static image (approximately 1883).
26 "Rider." Multiple exposure (approximately 1884).

ANTON GIULIO BRAGAGLIA

27 From the film *Thais*, suicide scene. Film (1916).
28 From *Thais*, the actress Thais Galitzky. Decor by Enrico Prampolini. Film (1916).
29 The "photodynamized" actress. Photodynamica (1911).
30 "Greeting." Photodynamica (1911).
31 "Figure on a Staircase." Photodynamica (1911).
32 "Youth Moving To and Fro." Photodynamica (1912).

KURT SCHWITTERS

33 "Heads of Children." Collage (1922).

ALVIN LANGDON COBURN

34 "Station Roofs, Pittsburgh" (1910).
35 Vortograph (1917).
36 "Ezra Pound." Vortograph (1917).

CHRISTIAN SCHAD

37 Schadograph (1918).
38, 39, 40 Schadographs; untitled (1918 to 1919).

RAOUL HAUSMANN

41 "The Art Critic." Collage (1919).
42 "Portrait of a Poet" (Paul Gurk). Collage (1919).

HANNAH HÖCH

43 "The Animal Trainer" (1930).
44 "The Cut of the Kitchen Knife." Detail from a collage (1919).
45 "OZ, the Tragedy." Collage (1919).
46 "Guarded." Collage (1925).
47 "The Dandy." Collage (1919).

MAN RAY

48 Rayogram.
49 Rayogram (1921 to 1928).
50 "Violon d'Ingres" (1924).
51 Untitled.
52 Rayogram, untitled.
53 Rayogram (1921 to 1928).
54 Rayogram (1923).
55 Rayogram (1921 to 1928).
56 Fashion photograph in *Bazaar*. Rayogram (1934).

JOHN HEARTFIELD

57 DADA. Collage (1920).
58 "After the Flood." Photomontage.
59 "I Know Only Paragraphs." Montage (1929).
60 "The Witching Hour." Montage (1930).

MAX ERNST

61 Sketch for a manifesto. Tempera and collage (1920).
62 "Self-portrait." Montage (1920).
63 "La Belle Jardinière." Photo-painting (1922).

LÁSZLÒ MOHOLY-NAGY

64 Photogram (approximately 1924).
65 Photogram (approximately 1927).
66 Photogram (1926).
67 "Leda and the Swan." Photoplastic (1925).
68 "Murder on the Rails." Photoplastic (1925).
69 "Jealousy." Photoplastic (1927).
70 Photoplastic (1927?).
71 "Self-portrait." Photogram (1926?).
72 Nude positive/nude negative (1931).

HERBERT BAYER

73 "Self-portrait." Photomontage (1932).
74 "Lonely City Dweller." Photomontage (1932).

EDOUARD L. T. MESENS

75 "Portrait of a Poet." Photogram and collage (1926).

SIEGFRIED FRANK

76 "The New Paradise." Photomontage, humorous photograph.

FRANCIS BRUGUIÈRE

77 "Rosalind Fuller with her Cello." Multiple exposure (1930).
78 Light abstraction (1928 to 1930).
79 Light abstraction based on a question mark (approximately 1929).
80 "St. George and the Dragon." Undated photodrawing.
81 Light abstraction (1928 to 1930).
82 "Girl in a Room." (1930).

PAUL CITRÖEN

83 "The City." Photocollage (approximately 1922).

Picture Credits

1 Collection André Jammes, Paris
2,3 Science Museum, London
4,5 Collection Société Française de Photographie
6,7,8 Scottish National Portrait Gallery
9 International Museum of Photography at George Eastman House, Rochester, New York
10 Royal Photographic Society Collection
11,12 Private collection
13,14 Bibliothèque Nationale, Paris
15 International Museum of Photography, George Eastman House
16,17 Royal Photographic Society Collection
18–23 Collection André Jammes, Paris
24 International Museum of Photography, George Eastman House
25,26 Collection Cinématèque française, Paris
27–32 Racc. A. Vigliano Bragaglia, Centro Studio Bragaglia, Rome
33 Privately owned
34,35 International Museum of Photography, George Eastman House

36 Private collection
37 Museum of Modern Art, New York
38,39,40 Galleria A. Schwarz, Milan
41 Estate Vordemberge-Gildewart
42 Original lost
43 Private collection
44 National Gallery, Berlin
45 Original lost, reproduction from the artist
46 Museum of Modern Art
47 Private collection
48–56 Owned by the artist
57–60 All rights: "Archiv Heartfield Berlin"
61,62,63 Privately owned
64–72 By permission of Gallery Klihm, Munich
73,74 By permission of the artist
75 Private collection
76 Privately owned
77–82 International Museum of Photography, George Eastman House
83 Prentencabinet Rijksuniversiteit, Leiden

Bibliography

General literature:

Walter Benjamin: *Das Kunstwerk im Zeitalter seiner technischen Reproduzierbarkeit,* Vol. I, Frankfurt 1955.
Walter Benjamin: *Kleine Geschichte der Photographie,* Frankfurt 1965.
Josef Maria Eder: *History of Photography,* New York 1945.
Helmut Gernsheim: *Creative Photography, Aesthetic Trends 1839 –1960,* London 1962.
Helmut Gernsheim: *The History of Photography,* London-New York 1955.
Raymond Lécuyer: *Histoire de la Photographie,* Paris 1945.
Thomas Neumann: *Sozialgeschichte der Photographie,* Neuwied-Berlin 1966.
Beaumont Newhall: *The History of Photography from 1839 to the Present Day,* New York 1949 (new edition: New York 1964).
Peter Pollack: *Die Welt der Photographie, von ihren Anfängen bis zur Gegenwart,* Vienna-Düsseldorf 1962.
Roger Simonet: *Cent Ans d'Images,* Paris 1947.
Otto Stelzer: *Kunst und Photographie, Kontakte, Einflüsse, Wirkungen,* Munich 1966.

Index

Abstraction, 9, 80
Académie des Beaux-Arts, 8
Académie des Sciences, 8
Adamson, Robert, 15
Alice in Wonderland, 15
Animal Locomotion, 79
"Anti-art," 82
Arago, Dominique François, 8, 14
Aristotle, 6
Arp, Hans, 82
"Art photography," 11, 16, 77

Baader, Johannes, 83
Baargeld, Johannes, 83
Balla, Giacomo, 81
Barbizon School, 78
Bauhaus
 Dessau, 85
 Weimar, 85
Bayard, Hippolyte, 14
Bayer, Herbert, 85
Berlin dimension, new, 83
Blanquart-Evrard, Louis Désiré, 78
Bourgeoisie, 10
Bragaglia, Anton Giulio, 81
Brecht, Bertolt, 83
Brewster, Sir David, 15
Bruguière, Francis, 86

Calotype, 13, 15
Camera lucida, 6, 12
Camera obscura, 6, 8, 11, 13
Cameron, Julia Margaret, 16, 77
Carroll, Lewis, 16
"Cartes de visite," 16
Chronograph, 80
Citroën, Paul, 85
City landscapes, 10
Cliché-verre technique, 78, 79
Close-up, 16
Coburn, Alvin Langdon, 81
Collage, 83-85
Communication, visual, 10
"Conquest of motion," 79
Constructivism, 80, 84, 86
Corot, Jean Baptiste Camille, 78
Cubism, 12, 81
Cubism, French, 81

Dadaism, 82-84
 Berlin, 83
 New York, 84
 Zurich, 82, 84
Daguerre, Louis Jacques Mandé, 8-10, 13-15
Daguerreotypes, 8-10, 14, 15
"Daguerreotypie," 8
Daubigny, Charles François, 79
David, Jacques Louis, 8
Degas, Edgar, 11, 12, 78
Delacroix, Eugène, 8, 11, 78
De Stijl, 85
"Diorama," 8
Dry plate, 14
Duchamp, Marcel, 83

Emigration
 actual, 86
 inner, 86
Encyclopédie (Diderot and d'Alembert), 7
Ernst, Max, 77, 83
Experiments
 photogenic, 82

photographic, 8, 82, 84
Expressionism, 12, 82
Expressionism, European, 80

Fauvism, 80
February Revolution, 10
Fenton, Roger, 15
Film technique, 80
Finsler, Hans, 86
Foto-Auge, 86
Frank, Siegfried, 86
Freund, Gisèle, 10
Futurism, 80
Futuristic Manifesto, 80

Gallery 291, 81
Gebser, Jean, 5
Genre photography, 10, 16
Géricault, Théodore, 8
Gernsheim, Alison and Helmut, 15
Gogh, Vincent van, 12
Grosz, George, 83

Hausmann, Raoul, 82, 83
Heartfield, John, 83
Heliographs, 8
Herschel, Sir John, 8, 13
Hill, David Octavius, 15, 16
Höch, Hannah, 83
Homo faber, 7

Images, 5
 moving, 79
 natural, 6
 positive, 9
 still, 79
Incunabula of photography, 9
Ingres, Dominique, 9, 11
Instant exposures, series of, 79
Itten, Johannes, 85

James, Philip, 15

Lenbach, Franz von, 11
Lenses, 13
Le Secq, Henri, 77, 78
Light, 5
 abstractions, 86
 sensitized papers, 13
 studies, 86
"Light drawings," 14
"Light graphics," 8, 85
"Light Requisite," 85
Lissitzky, El, 84
Lithography, 8, 83
London World Exhibition (1851), 15

Malerei, Fotografie, Film, 84
"Man and Dream," 85
Marey, Etienne Jules, 80
Megalopolis, 85
Mesens, Edouard L. T., 85, 86
Metropolis, 85

Microphotographic paper prints, 13
Millet, Jean François, 79
Moholy, Lucia, 85
Moholy-Nagy, Lászlò, 84, 85
Montage, 14
Motion structure, 80
Movement
 dynamic representation of, 80
 simultaneous portrayals of, 80
 single phases of, 77, 79
Multiple exposure, 80
Muybridge, Eadweard, 79-81

Nadar, 11
National Socialism, 83
"Nature prints," 8
Negative film, 14
Nègre, Charles, 77
Niepce, Nicéphore, 8, 9, 14
Nude representations, 9

"Objective photography," 86
Objectivism, 12
Objets trouvés, 82
October Revolution, 84
Op Art, 81
Optics, 5

Paris World Exhibition (1937), 86
Pawel, Karl, 86
Pencil of Nature, The, 14
Perspective
 age of, 5
 light or color, 5
 linear or central, 5
Peterhans, Walter, 85
"Photo and Film," (Stuttgart, 1929), 86
Photogram, 14, 82
Photographic language, 71
Photomontage, 16, 77, 82-86
Photoplastics, 85
Photo-Secession, 81, 86
"Physiotrace," 7
Pictorial photography, 81
Pinhole camera, 6
Pollack, Peter, 86
Pound, Ezra, 81
Printing, 7
Progressive art, 81

Querschnitt, 86

Ray, Man, 83-85
Rayographs, 84
Realism, emergence of, 6
Reality, new, 82
Rejlander, Oscar Gustave, 16, 77
Renaissance, 5-7
Reversal process, 13

Richter, Hans, 83
Rifle, photographic, 80
Robinson, Henry Peach, 77
Rodschenko, Alexander, 84
Roh, Franz, 86
Roll-film camera, 80
Rousseau, Théodore, 79

Salon paintings, 10
Salon, Paris
 1797, 7
 1861, 11
Schad, Christian, 82, 84
Schadographs, 82, 84
Schulze, Johann Heinrich, 7, 8
Schwitters, Kurt, 83
"Self-made image," 10
Shadow pictures, 7
Société Française de Photographie, 78
Solar microscope, 13
Still-lifes, 9, 77, 78
Stroboscope, 80
"Sturm" Gallery (Berlin), 88
Subjectivism, 12
Sunlight, 7, 13
Surrealism, 16, 83, 85
Surrealistic group (Paris), 84
Symbolism, 12

Talbot, William Henry Fox, 12-15, 78, 82
Talbotype, 13
Tatlin, Wladimir, 84
"The City," 85
"The Temple of Art," 16
Toulouse-Lautrec, Henri de, 12
Tschichold, Jan, 86
Typographia naturalis, 13
Typography, modern, 84
Tzara, Tristan, 82, 84

Valéry, Paul, 12
Victorian Age, 15, 16
Vinci, Leonardo da, 5, 6, 13
"Visualizations," 5
Vorticist group, 81
Vortographs, 81

Wedgewood, Tom, 8
Welt-Spiegel, 86
Wollaston, William Hyde, 6, 12
Working processes, study of, 80
World War I, 82, 84
World War II, 86

X-rays, 13

"Zoogyroscope," 79
"Zoopraxiscope," 79